YOUNG VINCENT

YOUNG VINCENT
The Story of Van Gogh's Years in England

MARTIN BAILEY

ALLISON & BUSBY

Allison & Busby
Published by W.H. Allen & Co. Plc

An Allison & Busby book
Published in 1990 by
W. H. Allen & Co. PLC
Sekforde House
175/9 St John Street
London EC1V 4LL

Typeset by Input Typesetting Ltd, London

Printed in Great Britain by
Butler & Tanner Ltd, Frome and London

ISBN 0 85031 965 X

The cost of the illustrations was partly funded by the Ralph
Lewis Award, University of Sussex Library.

Contents

Introduction

VINCENT VAN GOGH first fell in love in Brixton. It was just a few weeks after his twentieth birthday that the young Dutchman came to London to work for an art dealer in Covent Garden. In August 1873, soon after his arrival, Van Gogh found lodgings with the Loyer family and it was there that he became infatuated with his landlady's daughter, nineteen-year-old Eugenie. His first year in England was to be the happiest of his entire life. Ultimately, Eugenie spurned his advances and drove him to the depths of despair.

It was seven years before Van Gogh fell in love again, this time with his own cousin. She too rebuffed him in remarkably similar circumstances. Memories of Eugenie flooded back, and for the first time he talked openly with his brother Theo about what had happened so long before in Brixton. After this second rejection in love, he was able only to sustain relationships with prostitutes.

If Van Gogh's first love affair scarred him for life, what really happened in Brixton? Although more has probably been published about Van Gogh than any other artist in history, little has been written about his early years in England and the interlude he spent in Paris. Most biographies devote only a page or so to this crucial three-and-a-half-year period when the young Dutchman left adolescence behind him.

When I set out to investigate, I soon found that virtually all the information originated from a single source: Van Gogh's own letters, which had been published in 1914 along with a short introductory *Memoir* by his sister-in-law Jo Bonger, widow of his beloved brother Theo. Unfortunately, Van Gogh's surviving letters of the time never mention the love affair. Jo Bonger gives only a brief explanation of what happened in Brixton: Van Gogh 'fell in love with the daughter' at his lodgings, and when he discovered she was secretly

engaged, he 'tried to persuade her to break the engagement, but did not succeed.' Although tantalising, this account gave little away.

I decided to visit the Van Gogh Museum in Amsterdam to see if it might be possible to uncover some of the secrets of the artist's stay in England. There I saw the two hundred paintings which had been donated to the museum by his nephew, also called Vincent. These include many of Van Gogh's greatest works: pictures done under the influence of the Impressionists in Paris, with Paul Gauguin in Arles, at the asylum in Saint-Rémy-de-Provence, and during his last days at Auvers-sur-Oise. But what intrigued me, and what I hoped might help to provide some clues to these later paintings, were the 'unknown' drawings from Van Gogh's years in England.

Museum curator Han van Crimpen escorted me down to the underground vault of the museum and, closing the heavy metal door, explained that the early drawings are rarely seen. The sketches can only be displayed for short periods because they would otherwise fade, and some have never been exhibited. Besides, the public is much more interested in the great paintings of Van Gogh's later years. Even art historians have tended to dismiss these early sketches as 'juvenilia'.

Mr Van Crimpen pulled out several boxes, and carefully took out the drawings I had come to see. The small sketches looked extremely fragile. Their paper had faded to cream and the ink had turned brown. Although this little collection must have represented only a small part of Van Gogh's output during this period, it seems incredible that so much has survived. Surprisingly, many of the sketches have become known to art historians only since the 1960s, and it is therefore only now becoming clear that the young Dutchman drew regularly while in London.

What I saw fascinated me. There were sketches Van Gogh had done of the places he loved in England – the view from the window of the schoolroom where he taught in Ramsgate, the Dutch church in the City of London, a street scene in Isleworth, and the Methodist chapel at Petersham where he preached. There was a little sketchbook which he had assembled himself and then drawn in for the five-year-old daughter of his boss. There were also sketches of some of his favourite paintings: a Corot landscape which he had copied after the death of the artist, and a De Nittis picture of Westminster which featured one of his favourite motifs, an avenue of trees stretching towards the horizon.

The most intriguing drawing was a simple view of Hackford Road, the street in Brixton where Van Gogh lodged and fell in

love. The survival and discovery of this sketch is an astonishing tale. A London postman who loved Van Gogh's paintings had also been curious about the artist's early life in England. Though no one had found the house where Van Gogh lodged, through clever detective work he managed to track it down to 87 Hackford Road and to identify the name of the landlady's daughter, Eugenie. The trail led finally to one of Eugenie's granddaughters, an elderly woman living in Devon. When she was told that Van Gogh had fallen in love with her grandmother, she went up to the attic and fetched down a box of old family photographs.

There were some faded photographs of Eugenie, but the most exciting discovery lay in the bottom of the box: a drawing of Hackford Road which turned out to be by Van Gogh, sketched, presumably, in a bid to win her heart. Eugenie had treasured it, even after her marriage, and two more generations had saved the drawing, unaware of the identity of the artist. The family has now loaned it to the museum in Amsterdam. Seeing the sketch made me wonder if there were more works by Van Gogh still waiting to be discovered in England.

After I had examined the drawings, Mr Van Crimpen also showed me other reminders of Van Gogh's period in England. There was a battered scrapbook in which he had pasted engravings of his favourite pictures, giving a fascinating insight into his rather conventional artistic tastes at the time. Even more personal was a poetry album which he had filled for his brother Theo. There were seventy pages, carefully copied out in Van Gogh's neatest handwriting in Dutch, French, German and English. It was an early sign of the love which the two brothers had for each other.

In another corner of the vault there was direct evidence of how Van Gogh's later work was influenced by English art. A cabinet was filled with his collection of 1,500 prints, many of them from English magazines like the *Illustrated London News* and the *Graphic*. Van Gogh loved these 'black-and-white' engravings and they inspired him when he began to work as a full-time artist in the early 1880s. Although living in poverty, he spent his spare coins on buying these prints. Each of them was then carefully mounted on dark paper, a sign of the affection he lavished on his collection. Finally, in the underground vault there were many of the pictures which Van Gogh had done back in Holland under the inspiration of these English artists, including *Sorrow*, which portrays the prostitute he lived with in The Hague.

Although these 'finds' whetted my appetite, they did not really explain the crisis which Van Gogh had faced during his

stay in England. In the end, Mr Van Crimpen admitted there was one further source which might have some leads: a cache of unpublished family letters inherited by the artist's nephew and deposited at the museum after his death in 1978. These archives were closed, I was warned, and were available for inspection only with special permission.

No one had ever asked to see the letters from the 1870s, but if I was interested I could submit a written request. Two weeks later I was told that Dr Johan van Gogh, son of the artist's nephew, had granted me permission to consult the unpublished family correspondence. Returning to Amsterdam, I was astonished to find no less than four hundred letters from these three and a half years. Reading them with the help of my translator Jaap Woldendorp immediately brought me closer to the Van Gogh family. Here I was, sharing their secrets and looking at letters which had lain virtually unread for over a century.

All the letters were addressed to Theo, who like Vincent was working for Goupil's art gallery. Theo had left home at the beginning of 1873, when he was fifteen, to join their gallery in Brussels; he later took over Vincent's job in The Hague. The Van Gogh parents were living at Helvoirt, in the south of Holland, and since Theo came home only occasionally, letters were the way to keep in touch.

The parents wrote every few days, usually together on a single sheet of paper folded in half. Theodorus, who was 51, was a Reformed Church priest, and his letters are those of a caring father with liberal views, rather different from the strict, puritanical figure Vincent described when relations between them had soured a few years later. Anna was two years older than her husband. Her letters are more rambling and she seems less sophisticated. Nevertheless she comes across as a loving mother who cared deeply for her family.

The cache of correspondence also included letters from Vincent's eldest sister Anna who was at boarding school in Leeuwarden, in the north of the Netherlands. I was astonished to find that some of her letters were written in English. Reading the correspondence soon revealed the reason; on one occasion Anna complained that her teacher Miss Plaats made her write in English for practice. This soon came in useful. After she left school she went to England to look for work, finding a job as a teacher in Welwyn. Her letters are particularly important because they include the first references to the landlady's daughter Eugenie.

From reading the correspondence, it becomes clear that Vincent was constantly in his family's thoughts and over half the

four hundred letters from this period include some reference to him. Mother and Father would pass on news about what Vincent was doing in England. If they had not heard from him for a few days they would express concern, and when there were longer periods without news, they would soon get agitated.

The correspondence increased my curiosity about Van Gogh's stay in England. Back in London, I decided to try to track down the descendants of the people he had known. Over 110 years later, this meant finding the grandchildren – and more often the great-grandchildren – of his friends. When I finally reached them, it was fascinating to hear about the people Van Gogh had been close to in England.

The most poignant reminder of this period in Van Gogh's life was shown to me by another of Eugenie's granddaughters, Mrs Molly Woods. Searching through family papers, she unearthed a drawing which she thought could be of interest. It was by Samuel Plowman, the previous tenant in Brixton who later became Eugenie's husband, and it showed three children on horseback. Holding it up to the light, I could just make out the date 1874, the same year that Van Gogh sketched Hackford Road. It seems that the young Dutchman was not the only artist who wooed the landlady's daughter.

I was now beginning to build up a picture of Van Gogh's stay in London: his failed loved affair with Eugenie, his subsequent dismissal from the art gallery, and his growing obsession with religion. The main part of the book tells this story, seen through Van Gogh's eyes and where possible told in his own words. I was also curious to assess the impact of Van Gogh's time in England on his later years, particularly on his paintings, and this forms the basis for the final chapters.

Van Gogh was deeply affected by English writers, particularly Victorian novelists such as Dickens and George Eliot. Throughout his life, he continually re-read his favourite English books and on some occasions they helped provide the atmosphere that he was trying to capture in a painting. His job as an art dealer also brought him into close contact with English artists. Painters such as Richard Bonington, George Boughton and John Millais left a lasting impression on him. More significantly, he was introduced to the 'black-and-white' English magazine illustrators that were to be a major influence when he became a full-time artist.

Van Gogh was the only Post-Impressionist who was steeped in English culture. It is true that the main cultural influences on him were Dutch and French, and art historians have rightly concentrated on looking at his work from this perspective.

Nevertheless, focussing on Van Gogh's English influences can sometimes provide unexpected insights into his paintings.

In England, three 'loves' dominated Van Gogh's life. There was his love of God, his love of art, and then of course Eugenie. Her rejection profoundly affected his attitude to women. His obsession with religion, which intensified after the crisis with Eugenie, precipitated his two-year retreat to the Belgian coal-mining region of the Borinage, where he lived as a pauper to preach the gospel. His failure as an evangelist finally turned him towards art, and it was then that his years with Goupil's were to colour his attitude towards the commercial art world and to encourage him to pursue his own very personal artistic path. By focussing on Van Gogh's period as a young man in England, we can see his later life – and his paintings – in a fresh perspective.

In writing this study, I would like to express my thanks to the Rijksmuseum Vincent van Gogh in Amsterdam, particularly to Dr Ronald de Leeuw, Han van Crimpen, Louis van Tilborgh, Fieke Pabst and Anita Vriend. Most of Van Gogh's drawings from his English period are held by the museum, and I was kindly granted permission to reproduce them. This book is the first to illustrate all the artist's drawings of these early years and those in Part I are reproduced the same size as the originals (except for illustration 17b). I am very grateful for a financial contribution from the Ralph Lewis Award towards the cost of obtaining the photographs for the book.

I would also like to thank Dr Johan van Gogh of the Vincent van Gogh Foundation for allowing me to consult the unpublished family letters. My special thanks go to Jaap Woldendorp, who translated the correspondence. Little, Brown and Company kindly granted me permission to quote from the published Van Gogh letters. References to the letters cited in the book are given at the end. Other quotations are from sources listed in the bibliography or from interviews.

Clive Allison of W. H. Allen encouraged me with his enthusiasm for this study. Yoke Matze kindly took the photographs of the surviving houses where Van Gogh stayed in England and Sue Adler helped with other photographic work. I would also like to thank Ruth Brown, Onelia Cardettini, Paul Chalcroft, Susanne and Jesper Garvin, Anthony Green RA, Dominique Janssens, Stephanie Knapp, Marjorie Lawrence, Kathleen Maynard, Professor Ronald Pickvance, the Reverend John Taylor, Arthur and Marjorie Smith, Mark Williams and Molly Woods. Above all, my special thanks go to Alison Booth for her warm encouragement and support.

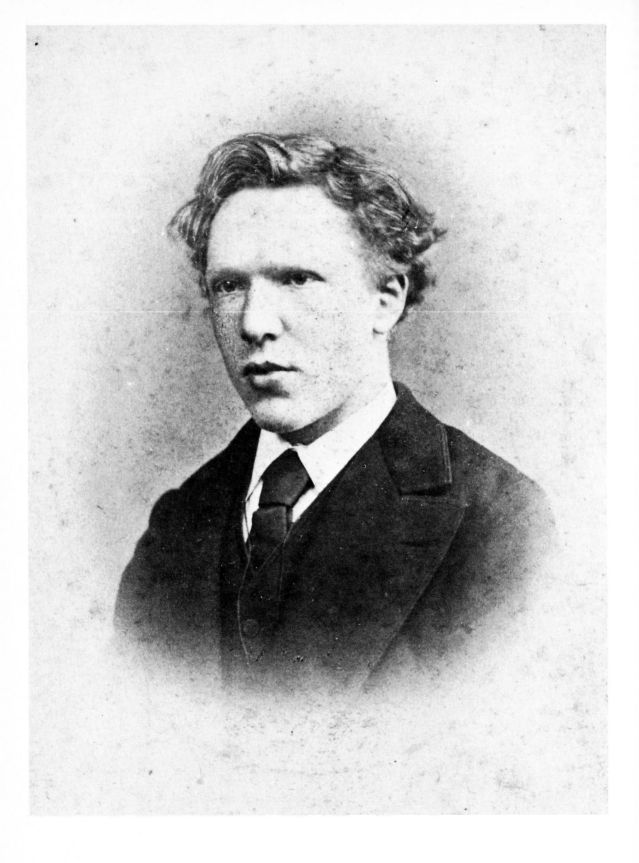

AN ART DEALER IN ENGLAND

1. Vincent, aged nineteen. This is the last surviving photograph of him, probably taken in January 1873, four months before he left for England. *'It will be quite a different life for me in London, as I shall probably have to live alone in rooms. I'll have to take care of many things I don't have to worry about now.'* – Vincent to Theo, 17 March 1873.[1]

First Impressions

'I am looking forward very much to seeing London, as
you can imagine, but still I am sorry to leave here. Now
that it has been decided that I shall go away, I feel how
strongly I am attached to The Hague. Well, it cannot
be helped, and I intend not to take things too hard. It will
be splendid for my English – I can understand it well
enough, but I cannot speak it as well as I should wish . . .
I am also curious to see the English painters; we see so
little of them because almost everything remains in
England.' –
Vincent to Theo, The Hague, 17 March 1873.[2]

WITH THESE HOPES, the young Vincent van Gogh arrived in
London. For four years he had worked for the art dealer Goupil
& Co, as an assistant at their gallery in The Hague. The London
job was a promotion, and he came with excellent references.
His boss, Hermanus Tersteeg, had written to his parents, prais-
ing him and saying that everybody liked to deal with him: art
lovers, customers and painters. Mr Tersteeg predicted he
would become a successful dealer at the company's expanding
London branch.

Over the weekend of 17–18 May 1873, Vincent unpacked his
trunk at his new lodgings. The first thing he did was to pin
up some prints which he had brought with him from The
Hague to make his bedroom feel like home. He then wrote to
his parents, telling them of his safe arrival, and they passed
on the news to his brother Theo. Mother explained to Theo
that his London boarding house was run by two women who
owned two parrots, 'one of which spoke English better than
Vincent.' Vincent was a rather serious young man and Mother
was obviously confused by her son's joke about his stilted
English. She explained laboriously that it must have been the
parrot rather than the landlady which spoke better English
than Vincent: 'I doubt if he meant the women. Uncle Cent
says that parrots kept indoors are very common and after
reading it again, it is very clear that it was the birds.'[3]

The whereabouts of Vincent's first lodgings remain a mys-
tery. London was then the world's largest city, with over 3
million people, and the suburbs were expanding rapidly. Vin-

cent's own description suggests that his boarding house must have been in one of the more pleasant parts of the sprawling city: 'The neighbourhood where I live is quite beautiful, and so quiet and intimate that you almost forget you are in London. In front of every house there is a small garden with flowers or a few trees, and many houses are built very tastefully in a sort of Gothic style. Still, I have a good half hour's walk to get to the country. We have a piano in the sitting room, and there are also three Germans living here who are very fond of music, which is very pleasant.'[4]

Vincent was impatient to discover the new city. 'One of the finest sights I have seen is Rotten Row in Hyde Park, where hundreds of ladies and gentlemen ride on horseback,' he wrote soon after arriving.[5] He was hardly, however, a conventional tourist: 'I have visited neither Crystal Palace nor the Tower yet, nor Tussaud's; I am not in a hurry to see everything. For the present I am quite satisfied with the museums, parks, etc; they interest me more.'[6]

Spring soon turned to summer, and most weekends Vincent would explore London and its surroundings. At Whitsun, he went for 'an interesting excursion' with the German lodgers. 'But these gentlemen spent a great deal of money and I shall not go out with them in the future,' he told Theo. The following Sunday, Vincent's new boss Charles Obach took him on a long excursion to Box Hill in Surrey. Vincent loved the scenery: 'It is a hill about six hours by road from London, partly of chalk and overgrown with box and on one side a wood of high oak trees. The country is beautiful here, quite different from Holland or Belgium. Everywhere you see charming parks with high trees and shrubs.'[7]

Despite the expensive tastes of his fellow lodgers, Vincent spent another day out with one of the Germans. On the summer bank holiday, 4 August, they went to Dulwich, 'an hour and a half outside London, to see the museum there, and after that we took about an hour's walk to another village. The country is so beautiful here; many people who have their business in London live in some village outside London and go to town by train every day.'[8] The museum they visited was Dulwich Picture Gallery, Britain's oldest public gallery, which has a splendid collection of seventeenth century paintings. Another Saturday, Vincent spent a 'glorious' day boating on the Thames with two English friends.[9]

Vincent's initial excitement at moving to London was soon tempered by a longing for Holland. For the first time he had to spend the summer holiday away from his family and, as he had feared, there were moments when he felt homesick and

depressed. He found comfort in his trusty pipe, which he had taken up just before coming to England. 'Theo, I strongly advise you to smoke a pipe; it is a good remedy for the blues,' he had told his brother.[10] His new boarding house failed to provide a real home. 'Moving is so horrible that I shall stop here as long as possible, although everything is not as good as it seemed to me in the beginning. Perhaps it is my own fault, so I shall bear with it a little longer,' Vincent wrote.[11]

Vincent badly missed his family and the Brabant of his childhood. He had been born in the village of Zundert, in the south of Holland, on 30 March 1853. This was exactly a year after his parents had had their first son, also named Vincent, who died at birth. As a child, Vincent often saw his elder brother's grave, inscribed with the same day of the year on which he was born. Every birthday he celebrated also marked the anniversary of his namesake's death.

In his early childhood Vincent was taught at home, but at eleven he was sent off to boarding school at Zevenbergen. Two years later he went to the secondary school at Tilburg and in July 1869 he started work at Goupil's gallery in The Hague. Vincent was intelligent, and although he had not done particularly well at school, he enjoyed reading. He was reasonably good at languages, and along with his native Dutch he spoke English, French and German.

Childhood had left Vincent a lonely soul, with few friends. His parents hoped that his shyness was just a symptom of adolescence, and that the move to London would do him good. Vincent was a very sensitive youth, but found it difficult to express his powerful emotions. Art had not yet provided an outlet.

When Vincent arrived in London he already looked much older than his twenty years. His furrowed brow gave him a soulful appearance. He was of medium height, with a tough, stocky body. His most striking feature was his piercing eyes, which had a penetrating glance that could be frightening. As his sister Lies described him, when he was a teenager he had 'a strange face, not young; the forehead already full of lines, the eyebrows on the large, noble brow drawn together in deepest thought. The eyes, small and deep-set, were now blue, now green, according to the impressions of the moment.'

Another vivid description of Vincent came from a friend with whom he shared a room a few years later. His fellow lodger P. Görlitz recalled: 'His face was ugly, his mouth more or less awry, moreover his face was densely covered with freckles, and he had hair of a reddish hue . . . But as soon as he spoke about religion or art, and then became excited, which

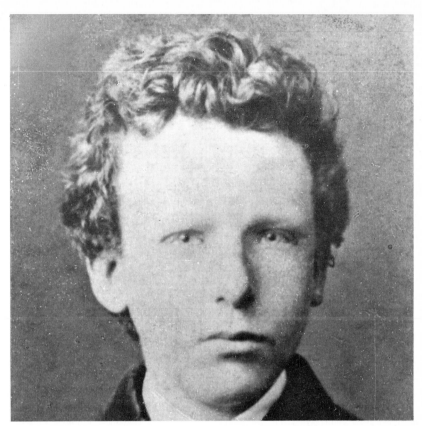

2. Vincent aged thirteen, when he had just started secondary school. 'If . . . *boyhood and youth are but vanity, must it not be our ambition to become men?'* – Vincent to Theo, 12 September 1875.[14]

was sure to happen very soon, his eyes would sparkle, and his features would make a deep impression on me; it wasn't his own face any longer; it had become beautiful.'[12]

When Vincent had set off for London, his family was living in Helvoirt, a small village near the North Brabant capital of 's-Hertogenbosch. His father, Pastor Theodorus, had been the Reformed Church priest there for two years and his mother Anna Carbentus helped her husband with his pastoral duties. They had provided Vincent with a secure middle class family home and had done their best to give him a happy childhood.

Vincent was the eldest child. After him, there was Theodorus (Theo), who was sixteen and had just joined Goupil's, working at their Brussels gallery. His three sisters – eighteen-year-old Anna, fourteen-year-old Elisabeth (Lies), and eleven-year-old Wilhelmien (Wil) – were all studying. Cornelius (Cor), the youngest in the family, had only just turned six.

Of all his brothers and sisters, it was Theo that Vincent missed most in London. Two months after his arrival, he recalled the time the previous year when Theo had visited him in The Hague and while on a walk to the nearby village of Rijswijk they had pledged to support each other forever: 'How I should like to have you here. What pleasant days we spent

17

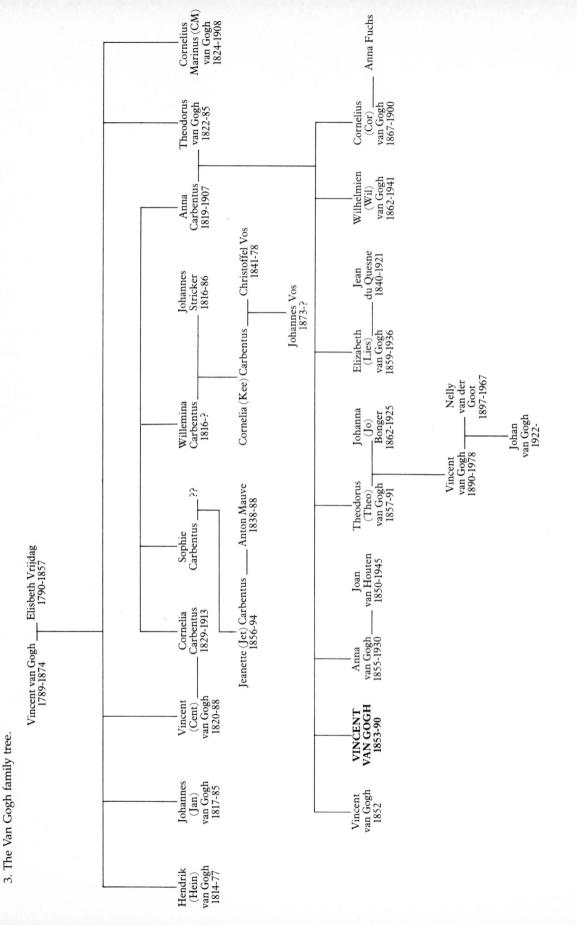

3. The Van Gogh family tree.

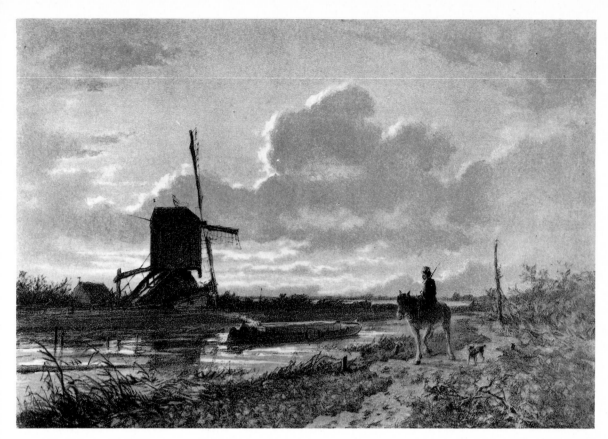

4. *Mill on the Rijswijk Road*, a lithograph by Hendrik Weissenbruch, depicting the place where Vincent and Theo made their pledge of brotherly support. *'I will send you a picture of that mill by Weissenbruch . . . That Rijswijk road holds memories for me which are perhaps the most beautiful I have.'* – Vincent to Theo, 20 July 1873.[15] together at The Hague; I think so often of that walk on the Rijswijk road, when we drank milk at the mill after the rain,' he wrote.[13]

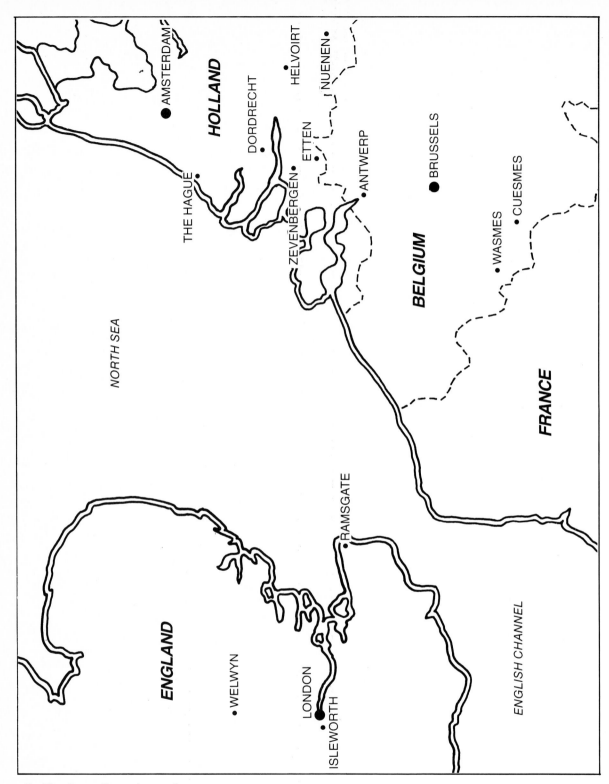

5. The Low Countries and south-east England.

20

Art Dealer

'I often think that if I had done as you did, if I had stayed with Goupil's, if I had confined myself to selling pictures, I should have done better.' –
Vincent to Theo, Saint-Rémy, 15 December 1889.[1]

GOUPIL'S GALLERY was at 17 Southampton Street, just between Covent Garden vegetable market and the Strand, where many of the art dealers and printsellers were based. The company had been founded in Paris in 1827, and by the 1870s it had become an important international gallery with branches in The Hague, Brussels, New York and London. Vincent could hardly have had a better start in the art trade. He dressed the part of a respectable dealer, wearing a top hat. 'You cannot be in London without one,' he told his parents.[2]

When Vincent moved to England, Goupil's London branch dealt mainly in prints: wood engravings, lithographs and photographic reproductions of popular paintings. These were fashionable among the rising middle class, who wanted to display their culture but could not afford original pictures. Vincent started as an assistant, on £90-a-year, but although

6. Goupil's gallery in The Hague, where Vincent began his career as an art dealer. Theo took over his job there when he was transferred to London. *'You will like the work in . . . The Hague as soon as you have got used to it.'* – Vincent to Theo, 19 November 1873.[9]

21

7. Uncle Cent, who arranged for Vincent to join Goupil's. *'In London, Goupil's has no gallery, but sells only directly to art dealers. Uncle Vincent will be here at the end of this month, and I am looking forward to hearing more particulars from him.'* – Vincent to Theo, 17 March 1873.[10]

8. Vincent gave Theo his new address in London. *'Don't forget to write V. W. van Gogh; otherwise it might be confused with Uncle Vincent's mail.'* – Vincent to Theo, 5 May 1873.[11]

much of his work was relatively menial, prospects for promotion were bright. Goupil's had ambitious plans in London to sell more original paintings and hoped to become one of Britain's leading galleries.

'We have had many pictures and drawings here; we sold a great many, but not enough yet – it must become something more established and solid. I think there is still much work to do in England, but it will not be successful at once,' he wrote to Theo. Characteristically, he added a note of uncertainty: 'Although the house [gallery] here is not so interesting as the one in The Hague, it is perhaps well that I am here. Later on, especially when the sale of pictures grows more important, I shall perhaps be of use. And then, I cannot tell you how interesting it is to see London and English business and the way of life, which differs so much from ours.'[3]

Vincent's decision to become an art dealer stemmed not from obvious artistic talent, but more from family connections. No less than three of his uncles were art dealers. Cornelius Marinus (known as CM) had a successful gallery in Amsterdam, while Hendrik (Hein), the eldest of his father's brothers, owned a gallery in Brussels which had been acquired by Goupil's in 1872. Most important of the three was Uncle Vincent (affectionately called Cent), who had arranged for his sixteen-year-old nephew to be taken on by Goupil's in The Hague. This shop had originally been owned by Uncle Cent, but although he had sold it to Goupil's in 1858 he continued to run it until ill-health had forced him to resign from day-to-day management in 1871.

Family links between Vincent's parents and Uncle Cent were close. Vincent's father had married Anna Carbentus, a sister of Uncle Cent's wife Cornelia. Uncle Cent and Cornelia never

V. W. van Gogh
Care of Messrs Goupil & C:
17 Southampton Street
Strand
London

had children, and it was assumed that if Vincent did well at Goupil's then he might one day inherit his uncle's share in the company. In 1873, it was Uncle Cent who suggested that Vincent should be moved to London because of it would give his young nephew the opportunity to make his mark.

When he arrived, Vincent's own artistic tastes were Continental. He loved Rembrandt and the Dutch seventeenth century masters. He also liked the nineteenth century French romantic landscape painters of the Barbizon School and Dutch artists of the Hague School. The Barbizon artists, who began in the 1840s, worked outdoors from nature and are now seen as the precursors of the Impressionists. Among Vincent's favourites were Charles-François Daubigny, Jules Dupré, Théodore Rousseau and most important of all, Jean-François Millet, along with two earlier artists who had influenced them, Jean-Baptiste Corot and Georges Michel.

The younger painters of the Hague School concentrated on landscape pictures in muted colours, portraying nostalgic images of rural life. Their popularity was at its height in the 1870s and Goupil's was one of their main galleries. Vincent particularly admired Jozef Israëls, the three Maris brothers (Jacob, Matthew and Willem), Weissenbruch and Anton Mauve. Once again family relationships were important in bringing him closer to the Hague School. His cousin Jet Carbentus was to marry Mauve on 26 November 1874 and this link was to prove of vital importance seven years later in The Hague. It was Mauve who then encouraged Vincent to take up painting and trained him in the use of colour.

Although curious about English art, Vincent's initial impressions were negative. English paintings, he complained, 'are with a few exceptions very bad and uninteresting.' In September 1873 he visited the Royal Academy summer exhibition, which even at that time had been providing a showplace for contemporary artists for over a century. Vincent told Theo about a picture he had seen of 'a kind of fish or dragon, six yards long. It was awful'. This painting was Sir Edward Poynter's *Fight Between More of More Hall and the Dragon of Wantley*. Another picture he mentioned was Valentine Prinsep's *Gadarene Swine*, which he dismissed as depicting 'fifty black pigs and swine running helter-skelter down the mountain, and skipping over one another into the sea.'[4]

'At first English art did not appeal to me; one must get used to it. But there are clever painters here,' he explained to Theo. Those he liked from the very start were Reynolds and Gainsborough ('whose forte was very beautiful ladies' portraits'), Constable ('a landscape painter . . . he is splendid')

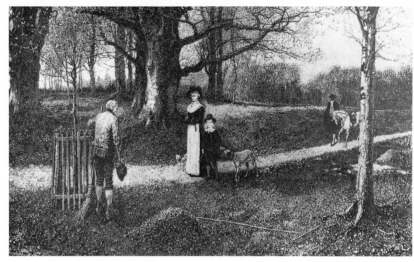

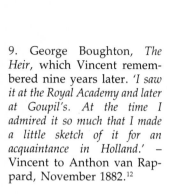

9. George Boughton, *The Heir*, which Vincent remembered nine years later. *'I saw it at the Royal Academy and later at Goupil's. At the time I admired it so much that I made a little sketch of it for an acquaintance in Holland.'* – Vincent to Anthon van Rappard, November 1882.[12]

Turner, Bonington and Millais, and above all, a now largely forgotten artist, George Boughton.[5] His admiration for Boughton began soon after his arrival, when he saw *The Heir*. Later, he spotted the painter in the street. 'I dared not speak to Boughton because his presence overawed me,' he recalled more than eight years later.[6]

Vincent's tastes in contemporary art can be gauged from the pictures at the following year's Royal Academy summer exhibition which were to make a lasting impact on him. At the time he singled out only one painter by name, mentioning the three canvases by James Tissot, a French-born artist living in London.[7] Depicting fashionable young people, the three Tissots were *London Visitors, Waiting* and *The Ball on Shipboard. London Visitors* must have had a special meaning for Vincent, because it depicted the steps of the National Gallery, which he would pass on his way to Goupil's.

From Vincent's comments made years later it is possible to identify several other artists who made a deep impression on him at the Royal Academy show. He loved Millais' *North-West Passage*, and in 1882 he recalled the words that the artist had inscribed below the picture of the old captain: 'It might be done, and if so, we should do it.'[8] There was also Frank Holl's *Deserted – A Foundling*, which had been based on an engraving from the *Graphic*. Another 'social realism' picture, also based on a *Graphic* illustration, was Luke Fildes's *Applicants for Admission to a Casual Ward*. This painting, with its strong emotional appeal, caused such a stir that it had to be protected from the crowds by a special railing. Finally, it was at the 1874 Royal Academy exhibition that Vincent saw Boughton's *God Speed!*, the work that was to dominate his view of English art.

24

a

b

10. Vincent's 'gallery' of favourite paintings from the 1874 Royal Academy summer exhibition. These included Tissot, *London Visitors* (a), Millais, *North-West Passage* (b), Holl, *Deserted – A Foundling* (c), Fildes, *Applicants for Admission to a Casual Ward* (d). *'There are beautiful things in the Royal Academy this year.'* – Vincent to Theo, 16 June 1874.[13]

c

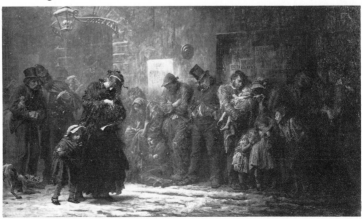

d

Moving to Brixton

*'In London how often I stood drawing on the Thames
Embankment, on my way home from Southampton
Street in the evening, and it came to nothing. If there had
been somebody then to tell me what perspective was,
how much misery I should have been spared, how much
further I should be now!'* –
Vincent to Theo, Drenthe, autumn 1883.[1]

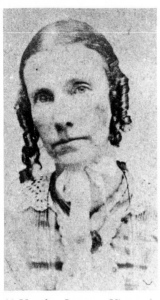

11. Ursula Loyer, Vincent's landlady. Although originally thought to be a photograph of Eugenie, the style of the clothing suggests that it dates from the early 1850s and is her mother Ursula. *'I live with a very amusing family now; they keep a school for little boys.'* – Vincent to Theo, 13 September 1873.[5]

AT THE END OF AUGUST 1873 Vincent moved into new lodgings in Brixton, on the outskirts of London. On his arrival, he compared his new room to the attic one he had known as a young boy. 'I now have a room such as I always longed for, without a slanting ceiling and without blue paper with a green border,' he told Theo.[2] A few weeks later Vincent made sketches of his new home for his parents. 'Vincent sent us such a nice drawing of the street and the house where he lives and of the interior of his room so that we really can imagine how it looks,' Father told Theo.[3]

It was here that the young Dutchman first fell in love. Until recently, all that was known was what had been written by Vincent's sister-in-law Jo in 1914: 'He found a delightful home at Mrs Loyer's. She was the widow of a curate from the south of France; with her daughter she kept a small day school and had a few paying guests. Vincent felt great sympathy for the mother, fell in love with the daughter Ursula [sic], and spent a happy time with them, as the cheerful tone of his letters clearly shows. But Ursula was already secretly engaged; when he heard this, Vincent tried to persuade her to break the engagement, but he did not succeed. In July 1874, he came home for the holidays in a melancholy, depressed mood. From that time on there was a change in his character: he inclined more and more towards religious fanaticism and led a secluded life.'[4] Jo's account of these crucial events is frustratingly brief, and to add to the confusion, it turns out that she also gave the landlady's daughter her mother's name.

It was not until almost a century after Vincent fell in love that the real story about the Loyers began to emerge, thanks to the curiosity of a London postman. Paul Chalcroft is an enthusiastic amateur artist who loves Vincent's pictures. After

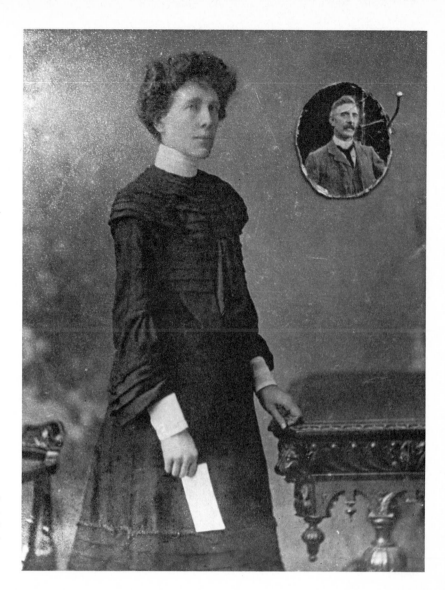

12. Eugenie with an inset photograph of Samuel Plowman. '*A man and a wife can be one, that is to say, one whole not two halves*' – Vincent to Theo, 31 July 1874.[6]

his delivery rounds, he works in the kitchen of his Camberwell flat, painting copies from postcard reproductions. Nearly twenty years ago, Chalcroft became curious to know more about the artist he admired. He was intrigued to learn that Vincent had spent his early years in London, but was disappointed to find that the whereabouts of the house where Vincent had fallen in love were unknown. In 1971, during a long postal strike, the 46-year-old postman set out to solve the mystery.

'Vincent was twenty when he moved to the Loyers, so Ursula – for that was assumed to be the name of the daughter – must have been about the same age, or maybe a little younger,' Chalcroft reasoned. He first went to the national birth regis-

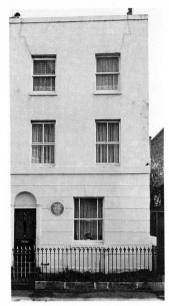

13. Number 87 Hackford Road today. After postman Chalcroft's discovery, a blue plaque was placed on the house where Vincent fell in love. *'I have a delightful home, and it is a great pleasure to me to study London, the English way of life and the English people themselves.'* – Vincent to Theo, January 1874.[7]

tration records to check the entries for the 1850s. Fortunately Loyer is a very unusual name in London, and the only one listed was Eugenie, born on 10 April 1854. This was the right period, since it would have made her just a year younger than Vincent, but·it was the wrong Christian name. Chalcroft studied the birth certificate, and found that her parents were Jean Baptiste Loyer, a professor of languages, and Sarah Ursula. He thought that perhaps Jo had confused the name of mother and daughter when she wrote her account forty years afterwards.

'I tried to identify the previous lodger to whom the daughter had been secretly engaged,' Chalcroft explained. Checking marriage records, he found that Eugenie Loyer had married at St Mary's church, Lambeth, on 10 April 1878, her twenty-fourth birthday. Her husband was Samuel Plowman, an engineer. The address of both of them was given simply as Hackford Road, Brixton, with no street number.

Chalcroft went back to the birth records to see what had happened next. The search did not take long, because Eugenie turned out to have been pregnant when they married. Frank, their first child, was born just six months later, on 18 October 1878. Curiously, the birth certificate showed that the baby was born at 87 Hackford Road, while the father was resident at number 17 in the same street.

Census records filled in the next piece of the puzzle. They are only opened after a century has elapsed, but fortunately Chalcroft did not have to wait. On 2 January 1972, he went to the Public Record Office to examine the returns for Hackford Road. Listed at number 87 in 1871 was Sarah U. Loyer, a '46-year-old' widow, and her sixteen-year-old daughter Eugenie (there was a misunderstanding about Ursula's age, because her death certificate suggests that she was actually 56 at the time of the 1871 census). This was the final confirmation that Vincent must have lodged at 87 Hackford Road.

The mystery of number 17 remains unsolved. Samuel might have found accommodation there when he left the Loyers, and he would then have been just down the road while Vincent was wooing Eugenie. Another possibility is that Samuel and his new wife moved there when they married, with Eugenie returning to her mother's house to give birth. More likely, the '17' was simply a clerical error for '87', because when the 1881 census was taken, Ursula, Eugenie and Samuel were all living together at number 87.

After Chalcroft had pinpointed the Loyers' home, he visited Hackford Road and found that number 87 was still standing, a three-storey terraced house. It must have been a comfortable

28

home in a middle class area when Vincent arrived. Although the Georgian building was then already fifty years old, it was a large house for just the two Loyers. They must have used the ground floor for their small school, but there was still room to take in lodgers.

The present residents of number 87, Arthur and Marjorie Smith, were astonished when Chalcroft knocked on the door and told them of the illustrious tenant who had once stayed there. The Smiths took the postman upstairs and showed him a small room on the top floor, facing the front. 'When we moved in back in the 1950s, the family who were leaving said it was always known as The Lodger's Room,' Mrs Smith explained.

Since Chalcroft's discovery, further investigations have revealed a little more about the Loyers. Jean Baptiste Loyer was born at Sainte Cecile in the south of France in 1801. Originally a Protestant curate, he probably came to London in the 1840s to work as a French teacher. In 1849 he married Ursula Wilson, a captain's daughter who had been born in 1815. Mr Loyer retired from Stockwell Grammar School in 1858, dying soon afterwards. Ursula, who was 58 when she took Vincent in, earned her living by running a small school for young boys at their home in Hackford Road.

Some sources claim that Mrs Loyer's nineteen-year-old daughter ran a dolls' shop, and this was reported as early as 1924 by Louis Piérard in his book *The Tragic Life of Vincent van Gogh*. Although it is possible that this information came from Jo, who died that year, there is no evidence to suggest that Eugenie was ever 'the angel of the little dolls', as Piérard put it. The truth is probably rather more prosaic. When Vincent arrived, she had recently finished her education and was helping her mother run the school.

Chalcroft's discovery of the Hackford Road address was soon overtaken by a more sensational find. Scottish journalist Kenneth Wilkie, who was writing the story of Vincent's life for *Holland Herald* magazine, decided to try to trace the descendants of Eugenie and Samuel. They had had three daughters, but because all had married Englishmen with common surnames it would have been very difficult to track down their descendants. Harold, their second son, had died at the age of two. This left their first child, Frank Plowman, whom Wilkie found had died in 1966 at Biggin Hill, Surrey, at the age of 87. Fortunately, his death certificate contained a vital clue.

The informant who reported his death was recorded as Kathleen E. Maynard, and Wilkie realised that this might be one of Frank's daughters. He searched the Biggin Hill tele-

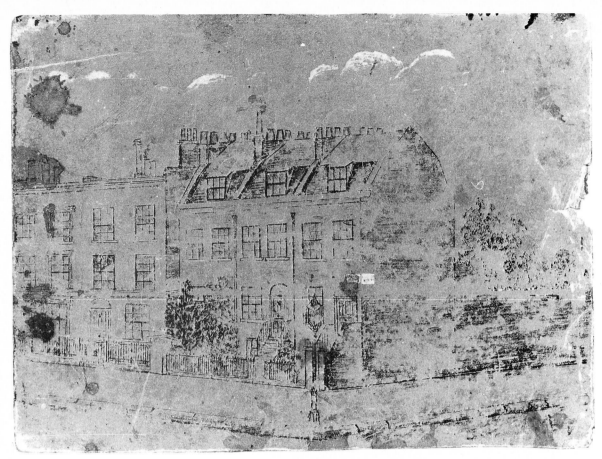

a

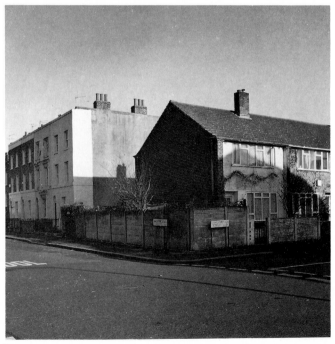

14. Vincent's recently discovered drawing of Hackford Road, with the Loyers' house fourth on the left. A photograph shows the gap left when the first three houses were bombed during the Second World War. *'Lately I took up drawing again, but it did not amount to much'* – Vincent to Theo, 16 June 1874.[8]

b

30

phone directory for a Kathleen Maynard. There was no one with the right initial, so he began ringing round the other Maynards. Just as he was giving up hope, a Dorothy Maynard answered the phone and admitted that she had a distant cousin called Kathleen. Wilkie, hardly able to believe his luck, was given her phone number in the Devon village of Stoke Gabriel. Kathleen Maynard confirmed that she was indeed Frank's daughter and, as a very young girl, had known her grandmother Eugenie.

Wilkie drove down to Devon in great excitement. When he arrived, Mrs Maynard brought out a box of old photographs which she had found in the attic. These included the first known pictures of Vincent's sweetheart, showing Eugenie as an imposing, tough-looking woman. Wilkie, in his book *The Van Gogh Assignment*, describes how Mrs Maynard was about to put the box away when he asked her if he could have a look through it himself. There was a little drawing, unsigned and stained with what looked like tea or coffee. It was soiled with age and a little frayed at the edges.

The drawing showed a terrace of five houses, sketched in pencil on blue paper and heightened with white. Wilkie, who had recently visited the Smiths, immediately recognised the scene, and closer examination revealed the words 'Hackford Road' and 'Loyer' inscribed on the sketch in tiny letters. It was unsigned, like all of Vincent's drawings of this period, but Wilkie immediately guessed the identity of the artist. Art historian Dr Hans Jaffé subsequently confirmed that it was indeed by Vincent van Gogh.

The Hackford Road sketch is the earliest surviving drawing from Vincent's English period. Vincent must have drawn the Loyers' house sitting outside the church that was then at the corner of Russell (now Hillyard) Street. The foliage on the trees suggests that it was either done very soon after Vincent moved there in August 1873 or, more likely, the following spring.

In 1988 a companion to Vincent's sketch for Eugenie was discovered. Although not having quite the art historical value of Vincent's drawing, it provided an intriguing new element to the story of what had occurred at the Loyers. I was having tea with seventy-five-year-old Mrs Molly Woods, another granddaughter of Eugenie, when she rummaged through family papers and found a quaint drawing of three little children sitting astride a horse. In the corner, only just visible, was the monogram 'SP' and the figures '74'. This confirmed family tradition that Samuel Plowman had been a keen amateur artist.

The year on Samuel's drawing showed it had been done

when Vincent lodged at Hackford Road. It provided the final confirmation that the man Eugenie married four years later was indeed the same person she had become engaged to when Vincent was in Brixton. Eugenie was being wooed by two artists, both of whom must have competed for her attention by presenting her with sketches. The drawings were lovingly treasured by Eugenie and, astonishingly, both survived for a century.

On seeing Samuel's horse, I wondered if he had drawn it from his imagination or whether it was a copy. It was difficult to know how to start identifying the picture, but quite by chance I discovered the answer just a few weeks later. While looking through back issues of the *Illustrated London News*, in the Christmas 1873 edition I suddenly came across Samuel's source, an engraving of a painting by Briton Rivière entitled *Equo de Credite Teucri* – 'Trojans, Trust not the Horse!'

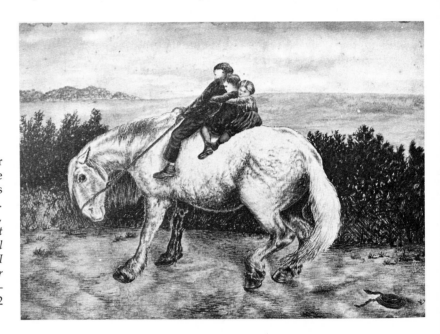

15.Samuel's drawing for Eugenie. Like Vincent, he wooed the landlady's daughter by drawing for her. *'In love one must not only give, but also take . . . I made that mistake once: I gave up a girl and she married another, and I went far from her, but kept her in my thoughts always. Fatal.'* – Vincent to Theo, 12 November 1881.[9]

Eugenie

*'What kind of love did I feel when I was twenty? It is
difficult to define — my physical passions were very weak
then, perhaps because of a few years of great poverty and
hard work. But my intellectual passions were strong,
meaning that without asking anything in return, without
wanting any pity, I wanted only to give, but not to
receive. Foolish, wrong, exaggerated, proud, rash — for
in love one must not only give, but also take.'* —
Vincent to Theo, Etten, 12 November 1881.[1]

VINCENT'S LOVE AFFAIR has remained shrouded in mystery.
None of his surviving letters mention the landlady's daughter,
although sensitive correspondence may well have been
destroyed. Nevertheless, the unpublished family letters give
the first hints about the dark 'secrets' of the Loyers. The first
and most intriguing reference to the landlady's daughter comes
in a letter from Anna to Theo, dated 6 January 1874. This was
just after the Christmas holiday, the first Vincent had spent
away from home. He had wanted to return to Helvoirt, but
Mr Obach had asked him to stay in London because the gallery
was very busy. Fortunately, the Loyers made their lonely
lodger feel welcome at their own celebrations.

Writing in her schoolgirl English, Anna passed on news
about the Loyers: 'Monday morning at breakfast I found a
letter from London, which contained a letter from Vincent and
one from Ursula Loyer, both were very kind and amiable. She
asks me to write her and Vincent wished very much we should
be friends. I'll tell you what he writes about her.'

Anna then continued, quoting directly from Vincent's
Dutch, presumably to avoid having to struggle with English.
Vincent had written to her: 'Ursula Loyer is a girl with whom
I agreed we should be brother and sister. You should also
consider her as a sister and write to her, and I think if you do,
you will soon discover *what* she is like. I won't say anything
more other than I have never seen nor dreamt about such a
love between her and her mother . . . You must not think
there is more behind this than I have written.'

The tantalising fragments which Anna quoted only reveal
part of what Vincent wrote, but it was this letter which con-

My dear Theo,

The first letter I shall write will be yours my dear boy; to tell you still once, what a pleasure you made me by coming in Utrecht. I was so glad to see you and hope so very much, you will be pleased more by your work, in 's Gravenhage It will go better every day I hope, and you will be more accustomed to it when still one month will be passed.

Monday morning at breakfast I found a letter from London, which contained a letter from Vincent and one from Ursula Loyer, both were very kind and amiable. The asks me to write her and Vincent wished very much we should be friends. I'll tell what he writes about her. "Ursula Loyer is een meisje met wie ik afgesproken heb dat wij beiden elkaars broeder en zuster zouden zijn. Jij moet haar ook als een zuster beschouwen en aan haar schrijven, en ik denk dat je dan spoedig zult ondervinden, wat zij is. Ik zeg niets verder, dan dat ik

16. Anna's letter of 6 January 1874 to Theo. It was then that she reported Vincent's comments which suggested he had fallen in love. *'Don't say anything about it to the parents. I have to do that myself.'* – Vincent to Anna, early January 1874.[7]

34

nooit iets gezien en gedroomd heb dan de
liefde tusschen haar en hare moeder"
Here follows a description of Christmas
en New-year and then still the following
phrase. "Old girl je moet niet denken
dat er meer achter steekt, dan ik je geschreven
heb; zeg er echter niets van aan huis, ik moet
dat zelf doen. Alleen nog eens, heb dat meisje
lief vor momentvil." I suppose there will be
a love between those two, as between Agnes
and David Copperfield. Although I must
say, that I believe there is more than a
brother's love between them; I send you
here Ursula's letter and so you can judge
for yourself. I hope you will send it
back very soon with a long epistle of
yourself I am so glad we have seen each
other again, what a nice time we spend
together, I'll never forget it, I hope you
amused yourself still the other part of
the evening. What have you done, did

vinced her that he had fallen in love. 'I suppose there will be a love between those two as between Agnes and David Copperfield,' she wrote to Theo. In Dickens's story, Agnes and David, though not brother and sister, are brought up together. Many years later, after David's wife dies, they finally marry. Anna concluded: 'I believe there is more than a brother's love between them. I send you here Ursula's letter and you can judge for yourself.'[2]

It is difficult to explain why Anna had called the landlady's daughter 'Ursula'. Eugenie's birth was not registered with the middle name Ursula, and there is no indication that her mother called her by this nickname. Anna's mistake in giving Eugenie her mother's name is all the more surprising because she had Vincent's letter in front of her when she wrote to Theo. Quoting directly from it, she then enclosed it in the same envelope to Theo (he presumably returned it to her and it has now disappeared). Although the mystery of the mix-up remains, this letter explains why forty years later Jo wrote in her *Memoir* that the landlady's daughter was 'Ursula', a mistake which is still repeated in some biographies.

On 24 February 1874, Anna wrote to Theo again, this time giving the correct name to the daughter: 'I also got a very kind letter from Eugenie'. Anna then added: 'Vincent wrote to me that she was engaged with a good natured youth who would know how to appreciate her.'[3] This acceptance of Eugenie's engagement is astonishing, given later developments.

The next mention of the Loyers came on 17 March, in Mother's letter to Theo. After saying that she hoped Vincent would have a good Easter in London, she added that the 'old lady', Mrs Loyer, had written to Anna, who was then looking for work in England. The Loyers 'say that Anna should regard their home as her own if she found something suitable near by,' Mother explained.[4]

On the face of it, the Loyers were very friendly towards Vincent, but something was amiss. On 30 March he celebrated his twenty-first birthday, and his loving family sent a box containing buttercake, chocolate and six pairs of cuff-links. But Vincent hardly seems to have been in a celebratory mood on the day he came of age. Writing to Theo on his birthday, he perfunctorily thanked his brother for 'a guilder from you for a pair of cuff-links.' At the end of the short note, he concluded: 'I, too, am very busy just now and am glad of it, for that is what I want.'[5]

A few days later, on 10 April, there was another birthday at Hackford Road, one which went unrecorded in Vincent's surviving letters. Eugenie turned twenty and by coincidence

her fiancé Samuel became twenty-two on the same day. For Vincent, it must have been frustrating to be so close to Eugenie, sleeping in a room just above her, while she remained so elusive.

Three days later Vincent wrote to Theo: 'I walk as much as I can, but I am very busy. It is very beautiful here (though it is the city). The lilac and hawthorn and laburnum are in bloom in every garden, and the chestnut trees are beautiful. If one really loves nature, one can find beauty everywhere. But still I sometimes long for Holland, and especially for home. I am very busy gardening and have sown a little garden full of poppies, sweet peas and mignonette. Now we must wait and see what comes of it.'[6]

CHAPTER 5

Unrequited Love

*'Because love is so strong generally in our youth
(I mean at 17, 18, or 20 years) we are not strong
enough to keep going straight! The passions are the
little ship's sails, you know. And he who gives way
entirely to his feelings in his twentieth year catches
too much wind and his boat takes in too much
water.'* –
Vincent to Theo, Etten, 12 November 1881.[1]

ON 27 JUNE 1874 VINCENT returned home to Holland to see his family. He had been away in England for just over a year, and as spring came, he was impatient to see Helvoirt again. Vincent had recently become deeply engrossed in drawing and he spent much of the time sketching during the short holiday with his family. Two of his drawings of Helvoirt survive, and he did other pictures which have disappeared. He also started to fill a little sketchbook for Betsy Tersteeg, the five-year-old daughter of his former boss in The Hague. She had been born the year that Vincent joined Goupil's and he had already done little drawings for her when he was working in Holland.

The existence of the Helvoirt sketchbook was long forgotten until it was tracked down in the early 1960s by Polish art historian Anna Szymańska, who found it with Betsy's elderly daughter, Mrs M. van Rijswijk. The sketchbook was put together by Vincent himself from separate sheets of paper, and only half of the twenty-four pages have survived. The note which Vincent asked Theo to give to Betsy has also been found. 'Next Monday I will go with my little sister Anna to London again, back to the house I have drawn for you and then I will go again on the little steamboat which I have drawn,' he told the young girl.[2] Sadly, these two sketches have now disappeared from the sketchbook. Other pages were left blank, because Vincent did not have time to complete the book, and Betsy later added a few childish drawings of her own.

It is often said that Vincent's parents failed to appreciate his artistic talent, but this was hardly true in his youth. Vincent had drawn as a child, although only a few of these early sketches survive. Even after he joined Goupil's, his parents continued to encourage him to draw and on the day he

17. Two drawings of Father's church at Helvoirt, July 1874. The church and the vicarage still stand in the quiet Brabant village, which Vincent loved to visit. He gave one of the drawings (b) to his sister Wil, and it has since disappeared (and is known only through a poor-quality photograph). *'How pleasant Helvoirt looked . . . the steeple amidst the snow-covered poplars.'* – Vincent to Theo, autumn 1876.[14]

38

a

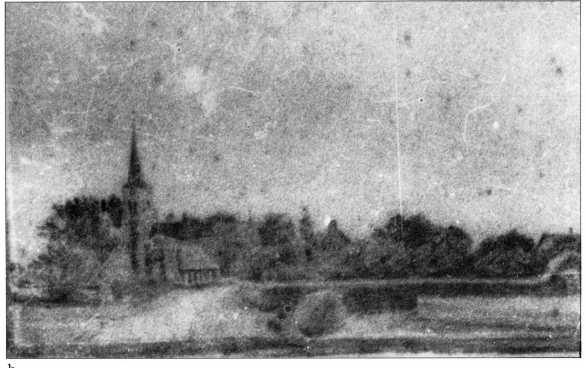

b

39

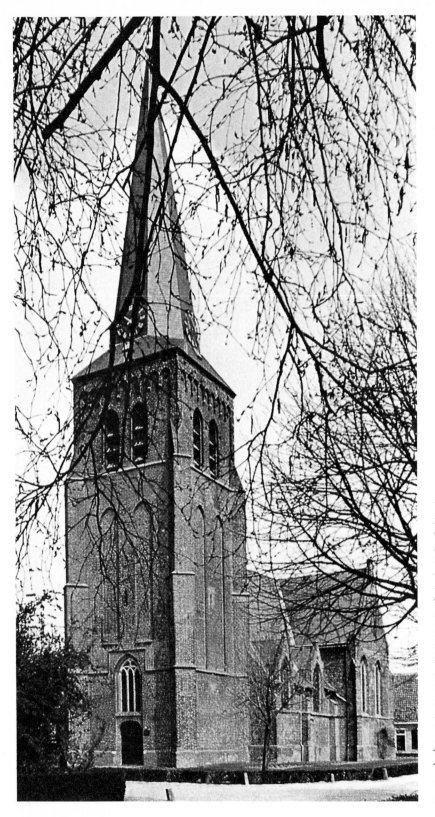

18. Vincent's sketchbook for five-year-old Betsy Tersteeg. One of the drawings was of a young girl, probably Betsy (a). Another showed a woman (possibly Anna) with trees and a church spire (b). There were two sketches of trees: one showing an avenue (c), a motif which often recurred in his later paintings, and another of a wood on the horizon (d). Finally there is a house, with childish squiggles which were probably added by young Betsy (e). *'My dear Betsy. I wanted to fill the whole book with drawings for you, but today Theo is leaving and I don't have time.'* – Vincent's dedication in the sketchbook, early July 1874.[15]

returned to London, Mother wrote to Theo explaining that he had given Lies a drawing of 'the bedroom window and part of the front door. They came out very nicely. And also for us a large sketch of the houses which their window looks out on in London. We are all very happy with it. It is a lovely skill which can be of much use'.[3]

Vincent was preoccupied during his summer holiday, spending much of his time sketching by himself. In her *Memoir*, Jo wrote that Vincent had already declared his love for 'Ursula' before he returned to Holland: 'Alas, it turned out that she was already engaged to the man who boarded with them before Vincent came. He tried everything to make her break this engagement, but he did not succeed. With his first great sorrow his character changed; when he came home for the holidays he was thin, silent, dejected – a different being. But he *drew* a great deal.'[4] Although Vincent did spend much of his holiday sketching, it was incorrect to claim that the crisis had already occured with Eugenie.

After a fortnight in Helvoirt, Vincent returned to London with his eldest sister Anna. She had recently finished school, and hoped to find work in Britain in order to practise her English. Anna had already written for jobs in Bristol, Gloucester and London, but none of her applications had been success-

a

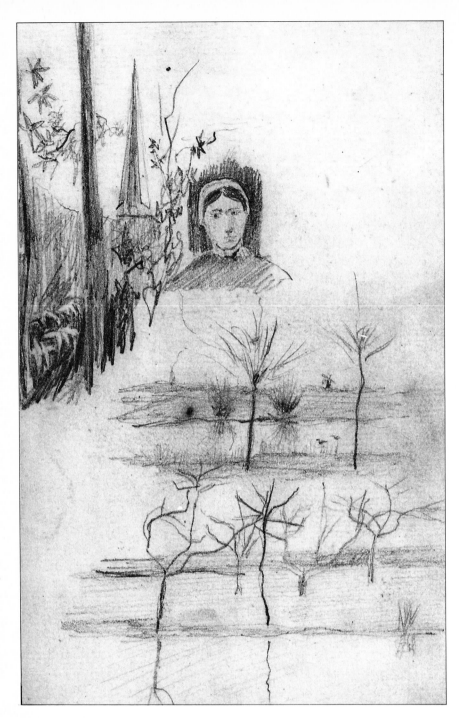

b

42

c

43

d

44

e

ful and she was told that it would be difficult to get a position unless she was already in England and available for interview. Vincent was enthusiastic about Anna's plans, encouraging her to return with him. 'I am longing to be closer to her than I am now. We have hardly seen each other for these last years, and we only half know each other,' he had written.[5]

After they arrived in England, on 15 July, Vincent showed Anna the sights. 'It is so beautiful here. You cannot compare London to any Dutch town. The houses are lovely and homely with gardens in front. Almost all the houses have ivy and climbing plants growing on them. I have already visited Vincent in the shop three times and have seen very beautiful paintings there . . . We are taking beautiful walks together. Now the evenings are shortening, it is almost prettier than during the summer,' she told Theo.[6]

Vincent and Anna had moved into Hackford Road, and when Anna wrote home at the end of July, everything was still going well. The Loyers, she said, were 'good people who are trying to make us as comfortable as possible.' Anna probably slept in the small room on the top floor, overlooking the back garden. She told her parents: 'I wish you could visit me in my little room. Yesterday evening, Vincent put up a lot of prints. It is very nice and comfortable. We walk every evening and always find beautiful new places. The fog which I used to imagine to be so horrible is also a beautiful sight, particularly in the morning when I accompany Vincent part of the way to his work.'[7]

The Loyers' warm welcome suggests that everything was going well. The first hint of Vincent's crisis over Eugenie only came in his letter to Theo of 31 July 1874. He did not refer to the landlady's daughter, but romance was obviously on his mind: 'A woman is a quite different being from a man, and a being that we do not yet know', but a man and a woman could become a close unit through marriage.[8]

The first weekend in August was a bank holiday, and on Monday 3 August Vincent took his sister to Dulwich Picture Gallery, the excursion he had made exactly a year earlier with one of the German lodgers. It may well have been over this weekend that Vincent declared his love for Eugenie. She was already engaged to Samuel, but perhaps with Anna's encouragement Vincent may have felt he could convince her to change her mind. Eugenie did not marry Samuel for four years, suggesting that she may not have been in a hurry to marry. Her secrecy could also have led Vincent to misunderstand her feelings about Samuel.

In his biography, Piérard claims that Eugenie cruelly mocked

Vincent: 'When one day he openly declared his love she replied laughingly that she was already engaged to be married. Vincent, losing his head, demanded that her engagement should be broken off, which provoked the "angel of the dolls" to laugh in his face even more loudly.' But although the story may have originated from Jo, her own *Memoir* does not refer to Eugenie's mocking reaction.

By 10 August, when Vincent wrote to Theo again, the crisis had already occurred. Vincent did not explain what had happened, but instead lectured his brother, apparently justifying sexual experience before marriage. He quoted from St John's Gospel: 'Ye judge after the flesh; I judge no man . . . He that is without sin among you, let him first cast a stone at her.' Vincent concluded his letter to Theo by announcing that he and Anna were leaving the Loyers.

Theo must have criticised his older brother's libertarian views, and Vincent reacted by bluntly telling him to mind his own business. 'Keep to your own ideas, and if you doubt whether they are right, test them with those of Him,' he wrote. Vincent justified his position by referring to a painting. 'Virginity of soul and impurity of body can go together. You know the *Margaret at the Fountain* by Ary Scheffer,' he told Theo.[9] The picture, which has not been previously identified, dates from 1858 and was bought by Sir Richard Wallace in 1872. Vincent must have seen it soon afterwards when it was exhibited at the newly-established Bethnal Green Museum, in the East End. Since 1875 it has hung at the Wallace Collection in London, where it is now catalogued as *Margaret at the Well*.

As the *Illustrated London News* delicately explained when Scheffer's painting went on show, it was inspired by Johann Goethe's *Faust*, and dealt with the story of a girl who 'has been detected in a lapse of feminine virtue'. Vincent described it using his own euphemism: the picture was about a girl 'who loved so much', the phrase he always used for prostitutes. In Faust's story, Margaret hears two friends gossiping about the pregnant Lisbeth. Margaret reflects how once she would have condemned Lisbeth, but now 'the reproach and sin are mine.' Vincent's message, encapsulated in Scheffer's painting, was that promiscuity should not necessarily be condemned.

Vincent believed that sexual intercourse outside marriage could be positive. Three years later he gave a theological explanation of his libertarian views: 'A man ought not to marry before his fortieth year or thereabouts: first the passions ought to be curbed before one may think of entering upon such a serious matter; one can only be a man in real earnest after the passions are conquered, for only then can one seek to be a

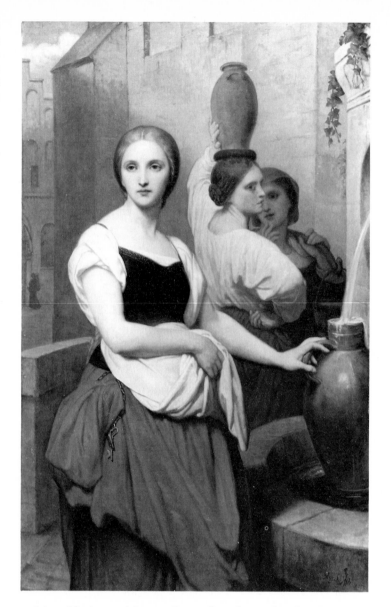

19. Scheffer's *Margaret at the Fountain*. Vincent used the picture to justify his acceptance of prostitution. *'Is there a purer being than that girl "who loved so much"?'* – Vincent to Theo, 10 August 1874.[16]

spiritual being with good results; the animal must get out, then the angel can enter.'[10]

Vincent's views must have shocked the young Eugenie, brought up in a respectable Victorian household, and may account for her determined rejection. Whatever occurred, the result of the crisis with Eugenie was to make Vincent consider sex with a girl 'who loves so much'. The first woman he made love to was probably a London prostitute.

Five days after Vincent's letter about the Scheffer painting, he and Anna had already moved from Hackford Road. Father wrote to Theo, understating the problems: 'It turned out at the Loyers that it wasn't alright.' He added that he didn't trust

48

the situation there, and he was pleased they had left. Mother was also relieved they had moved, and she was equally enigmatic: 'Vincent will not have had it easy at the Loyers. I'm glad he is not there. There are too many secrets there, and they are not a normal family. I am sure he will have experienced disappointment that his dreams were not realised.'[11] The reference to secrets – in the plural – is curious. It is difficult to see how Mother can have been thinking of Eugenie's engagement, since Vincent had told Anna about it six months earlier. The parents' uncharacteristic refusal to write frankly suggests that whatever happened at the Loyers was very difficult to face.

Vincent had been living in Brixton almost exactly a year before he revealed his infatuation for Eugenie. When he arrived, the twenty-year-old youth had never had a close relationship with a girl, and it is not surprising that he was attracted to the landlady's daughter, who was just a year younger. She was friendly towards him, and Vincent may have mistaken this for something more. Although the relationship was totally unconsummated, for Vincent it was definitely 'love'. As he later admitted, he always seemed to end up in love affairs that left him bitterly disappointed and humiliated.

What still remains unexplained is the enigmatic role of Eugenie's mother, perhaps the cause of the family's 'secrets'. Anna's curious use of the name 'Ursula' in her letter of 6 January 1874 suggests that there may have been some ambiguity in Vincent's comments, and this in turn might suggest confusion in his own mind. It is possible that Vincent may have also harboured deep feelings towards Ursula, as well as for her daughter?

There is a curious reference to older women in Vincent's letter of 31 July 1874, written only a few days before the crisis at Hackford Road. Vincent referred to the French philosopher Jules Michelet, who had died six months earlier. Commenting on *L'Amour*, he told Theo: 'To me that book has been both a revelation and a Gospel at the same time: "No woman is old" . . . a woman is not old as long as she loves and is loved.'[12] There was something that attracted Vincent to older women. Years afterwards, when he fell in love with the prostitute Sien, he wrote to Theo: 'Even as a boy I often looked up with infinite sympathy, with respect even, into a half-faded woman's face.'[13]

Perhaps the key to Vincent's emotions lies in the comment he made that he had never before 'dreamt' about such a love between mother and daughter. Vincent's feelings for Ursula may have become entwined with love for her daughter. Eugenie's rejection brutally shattered his love.

Alone in Kennington

*'I still go on having the most impossible, and not very
seemly, love affairs, from which I emerge as a rule
damaged and shamed and little else . . . I tell myself that
in the years gone by, when I should have been in love I
gave myself up to religious and socialistic devotions.'* –
Vincent to his sister Wil, Paris, mid 1887.[1]

'WE ARE GOING to move to a house quite covered with ivy,'
Vincent wrote to Theo on 10 August 1874.[2] After leaving the
Loyers, he withdrew into himself. Until now very little has
been known about this period because there is a gap of six
months before the next surviving letter to Theo. It was a period
of great depression and although Vincent wrote occasionally,
his letters have been destroyed. The unpublished family corre-
spondence therefore fills in important gaps in the story.

Vincent and Anna moved to Ivy Cottage, at 395 Kennington
Road, just a mile north of the Loyers (Jo misread the address
when she gave it in her *Memoir* as Kensington Road). Despite
the upheaval, Anna continued to search for work. 'I think it
will be very difficult to find anything for her. They say every-
where that she is too young, and generally German is required.
At all events, she has a better chance here than in Holland,'
Vincent told Theo.[3] A few days later Anna was offered a £12-
a-year post as an assistant teacher in Welwyn, a village twenty-
five miles north of London. The school had just been estab-
lished by Miss Caroline Applegarth in a beautiful Elizabethan
house, also called Ivy Cottage.

Once more, Vincent was alone. On 15 August, Mother wrote
to Theo: 'I am always worrying that Vincent doesn't look after
himself, especially when Anna will be gone. He was so
thin . . . They wrote that they had a lovely breakfast with
fried bacon. Who will fry that bacon now?'[4] Vincent's parents
became increasingly concerned about their son.

Despite his depression, Vincent continued to find fulfilment
in art. Thanks to a recent discovery, we now know that on 28
August 1874 he visited the British Museum's Department of
Prints and Drawings and is recorded in the visitors' book as
the fourth name that day. A comment which Vincent made
three years later makes it possible to identify the drawing

20. Visitors' book of the British Museum's Department of Prints and Drawings, together with the drawing he saw, Rembrandt's *Christ with Mary and Martha*. 'The figure of our Lord, noble and impressive, stands out serious and dark against the window, which the evening twilight is filtering through . . . I hope I forget neither that drawing nor what it seems to say to me.' – Vincent to Theo, 18 September 1877.[20]

a

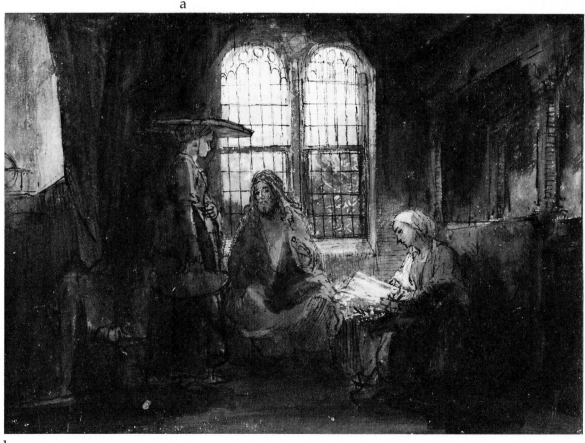

b

which he must have seen. In September 1877, while visiting the Trippenhuis' superb collection of Rembrandts in Amsterdam, he thought of the Dutch master: 'From the rich treasure of his heart he produced, among other things, that drawing in sepia, charcoal, ink, etc, which is in the British Museum, representing the house in Bethany.'[5]

After the crisis with Eugenie, Vincent's despair made him turn inwards, cutting himself off from the world. On 4 September Mother wrote to Theo: 'I wonder how Vincent is doing? The evenings are getting so long and he finishes work early . . . Uncle Cent thinks he should mix with other people for his development, that is just as important as becoming good at business.'[6] Vincent's parents became desperate about their eldest son, and Father explained to Theo: 'He appears to be in a depressed state of mind. Perhaps he should get a transfer for a short time to another place because he dislikes the London fog . . . I think the London air is doing him no good. Poor boy, he means so well but I believe that he makes things very difficult for himself.'[7] The family letters reveal for the first time the full extent of the anguish and depression which Vincent suffered.

Three days later Father wrote again to Theo, 'I recently heard Uncle Cent say that he [Vincent] ought to go to Paris to also get to know the business over there . . . this change in air and surroundings might be helpful.'[8] On 19 October Father announced that the move had been arranged: 'Vincent will go to Paris for a short time . . . From Vincent we received a letter dated 7 October, not yet very cheerful but let us hope that will change. He should not isolate himself too much.'[9] Mother was more outspoken, describing Vincent's letter as positively 'unfriendly'.[10] On 28 October, just before Vincent's departure, Mother wrote to Theo, commenting on the reasons for his depression. 'The secrets at the Loyers didn't do him any good . . . He has turned himself away from the world and people,' she explained.[11]

In mid-November Vincent was transferred for a month to Goupil's gallery in Paris. He did not want to leave London and on 20 November he sent his parents a short note from Paris in which he blamed them for the move. Five days later he posted them 20 francs, but without a covering letter. Jo later explained that Vincent was 'so angry that he did not write home, to the great grief of his parents.'[12]

Just before Christmas, Vincent was told that he could go on to Helvoirt for the holidays and then from there return to London. Anna was also coming from Welwyn and Theo from The Hague, making it a full family celebration. Vincent later

recalled his return in highly emotional terms, vividly remembering the moment he saw his parent's village: 'I drove from Bois-le-Duc ['s-Hertogenbosch] to Helvoirt in a little open cart, it was terribly cold and the road was slippery; how beautiful Bois-le-Duc looked, the market square and the streets covered with snow and the dark houses with snow on the roofs. Brabant is ever Brabant, and one's native country is ever one's native country, and countries of exile are ever countries of exile.'

Theo was now a mature seventeen-year-old, able to understand Vincent's concerns and fast becoming a source of strength to his older brother. As on their walk to the Rijswijk Mill, it was an excursion with Theo that proved to be one of the highlights of the holiday. 'We took a walk in the snow in the evening, do you remember, and saw the moon rise over the Mariënhof,' he wrote two years later.[13] Once again Vincent had poured out his troubles to Theo.

After the holiday, Vincent and Anna travelled back to England together, with Anna spending a few days with him in Kennington before going north to Welwyn. Unfortunately, they argued bitterly, and Anna later admitted to Theo that she would never have stayed if she had realised how moody Vincent would be. Four months later, Anna complained that Vincent judged people before he really knew them: 'If he then finds out what they really are and they don't live up to his quickly-made judgement, he is so disappointed that he throws them away like a bunch of old flowers, without looking to see whether beneath the dead flowers, there is more than . . . rubbish.'[14]

Whilst Vincent had been away in Paris, major developments had been taking place at Goupil's in London. Holloway & Son, a rival printseller, had been acquired and their shop at 25 Bedford Street was taken over for the enlarged gallery. This was very close to the old Goupil's shop in the next street down the Strand from Southampton Street. Goupil's now expanded the business of selling original paintings. 'Our gallery is ready now and is very beautiful, we have some splendid pictures: Jules Dupré, Michel, Daubigny, Maris, Israëls, Mauve, Bisschop, etc. In April we are going to have an exhibition. Mr Boussod has promised to send us the best things available,' Vincent told Theo.[15]

Soon after Vincent's return to London he went to an Old Masters show at the Royal Academy. 'There is a beautiful exhibition of old art here, including: a large *Descent from the Cross* by Rembrandt . . . *Autumn Evening* by Titian; 2 portraits by Tintoretto; and some beautiful old English art – Reynolds,

21. Millais' *Chill October*, which was auctioned at Christie's on 24 April 1875. '*I have always remembered some English pictures such as* Chill October.' – Vincent to Theo, August 1884.[21]

23. Corot's portrait, published to mark the painter's death. The copy which Vincent had on his wall in Kennington, with pinholes in each corner and a small tobacco burn, is in the Van Gogh Museum in Amsterdam. '*Today we are sending a box in which I have included . . . a portrait of Corot from the* London News, *which hangs in my room.*' – Vincent to Theo, 6 March 1875.[23]

Romney and splendid Old Crome landscape,' he told Theo.[16]

With Goupil's expansion in London, Vincent raised the possibility of getting Theo transferred there, although the idea was rejected by the gallery's directors. It was, however, a sign of the close relations that were developing between the two brothers. On 6 March Vincent sent Theo a notebook which he had filled with seventy pages of his favourite poetry and writings. He also enclosed an engraved portrait of the artist Corot, who had died two weeks earlier.

Soon after Corot's passing, death had a more personal impact on Vincent. Within a few weeks, it struck down no less than four young friends of the Van Gogh family. Tragedy came first in Welwyn. On 9 April, Ernest Stothard, the ten-year-old son of Anna's landlady, died of diphtheria. Just two days later, there was a death at the Kennington house where Vincent lived with publican John Parker and his family. Their young daughter Elizabeth died of pneumonia.

Vincent immediately walked five miles to Streatham Common, where he drew a sketch for Theo. He explained to his brother: 'Enclosed is a little drawing. I made it last Sunday, the morning when my landlady's little daughter died; she was thirteen years old. It is a view of Streatham Common, a large grassy plain with oak trees and gorse. It had been raining overnight; the ground was soaked and the young spring grass was fresh and green. As you see, it is sketched on the title page of *Poems* by Edmond Roche.'[17] This drawing has disappeared,

54

he stands thereby, though in the centre of immensities, yet manlike toward God & man; the vague shoreless universe has become for him a firm dwelling place which he knows.

The works of a man do not perish, cannot perish. What of heroism, what of eternal light there was in a man & his life, is with very great exactness added to the eternities, remains for ever a new divine portion of the sum of things..

Carlyle

Que lisons nous dans la génèse vénérable des Aryas, dans les hymnes de leur Rig-Veda, incontestablement le premier monument du monde —: "Deux personnes unies, l'homme la femme, d'un élan commun, remercient la lumière, chantent ensemble un hymne à Agni (le feu) .—
Merci pour le foyer, pour Agni, le bon compagnon, qui leur égaye l'hiver, fait sourire la maison; Agni le nourricier, Agni le doux témoin de la vie intérieure ."

Michelet Bible de l'humanité

22. Theo's poetry album, inscribed with Vincent's favourite writings. *'I have quite filled your little book, and I think it turned out well.'* – Vincent to Theo, February, 1875.[22]

although another sketch which was sent with the same letter has survived, a copy of Corot's *Ville d'Avray: L'Etang au Batelier*, Vincent's memorial to the artist.

There were also two tragic deaths in Holland. On 30 April, a fifteen-year-old schoolfriend of Lies died. 'The girl sat just next to her on Monday and was dead on Friday,' Mother told Theo.[18] Within a few days, a favourite teenage cousin of the Van Gogh children, Annette Haanebeek, died after a long illness in The Hague. Death dominated Vincent's thoughts. On 8 May, he ended a letter to Theo with an extract from the French philosopher Ernest Renan: 'Man is not on this earth merely to be happy, nor even to be simply honest. He is there to realise great things for humanity, to attain nobility and to surmount the vulgarity of nearly every individual.'[19]

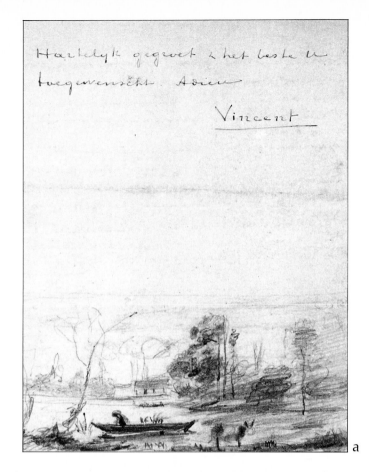

Hartelyk gegroet & het beste U
toegewenscht. Adieu
Vincent

a

b

24. Drawing based on a print of Corot's picture *Ville d'Avray: L'Etang au Batelier*, sketched at the end of a letter to Theo, with the engraving. Edmond Roche's poem, to which Vincent referred, was dedicated to Corot. *'You will probably be curious to know the one* [poem] *that describes the etching by Corot, and I am therefore copying it too: "We looked at the pond with its somber, leaden water, as it assembled in the breeze, fold after fold . . ."'* – Vincent to Theo, 18 April 1875.[24]

Transfer to Paris

*'I should go straight to Paris after March and start
drawing at the Louvre . . . I shall feel at home again in
Paris.'* –
Vincent to Theo, Antwerp, February 1886.[1]

ON 1 MAY 1875 VINCENT wrote a short note to his parents,
saying that Uncle CM and Mr Tersteeg had visited London.
They had obviously been considering Vincent's future, and he
felt uneasy. 'They went too often to the Crystal Palace and
other places where they had nothing particular to do. I think
they might just as well have come to see the place where I
live. I hope and trust that I am not what many people think I
am just now,' Vincent told Theo.[2]

Soon afterwards, Vincent was sent back to Paris again.
Another assistant called Tripp, who was working for Goupil's
in Paris, replaced him in London and originally the swap was
intended to last up to two months. Vincent was upset, particu-
larly as Goupil's had only just opened the inaugural exhibition
at their new Bedford Street gallery. 'For Vincent, it will be quite
a disappointment that he cannot work in London, especially at
this time,' Father wrote on 24 May 1875.[3]

Two weeks later his parents received what Father described
as 'a strange letter' from Vincent. 'It is making us rather wor-
ried. If only the heat and the effort didn't overstrain him . . .
I believe it is an illness, either in the body or the mind. We
are very worried, but we trust in God's guidance,' Father
wrote.[4] Lies was also concerned about the lonely plight of her
eldest brother. 'I understand what it is like to have almost no
one around who is sympathetic, who understands what goes
on in one's heart . . . I never had the chance to get to know
Vincent, but during this past holiday I have seen how he is . . .
such a good brother. Theo, I believe that we ought to . . .
follow his example,' Lies wrote to Theo on 30 May.[5]

At the end of June, Vincent's initial two-month period in
Paris was up, but he was warned that he would have to stay
on and there would be no chance of returning to Helvoirt for
the summer holiday. Fortunately, by this time Vincent had
become more reconciled to the French capital. Father told Theo
that there was 'a friendly tone in the short letter from

25. Goupil's gallery in rue Chaptal. *'At the office I do whatever I find to do; that is our task all through life, boy. I hope that I may always do it with all my strength.'* – Vincent to Theo, 11 October 1875.[14]

Vincent . . . and because of that we had a good afternoon yesterday'. He went on to explain that Vincent would stay in Paris: 'He doesn't think he will be able to come to Holland before the autumn. We are sorry that it will be so long . . . The bright side is that the directors of the company will get to know him well and he will do his best to make a good impression.'[6]

Anna returned from Welwyn in the middle of July to spend a month in Helvoirt. While she was there, it was decided that her youngest sister Wil, who was just thirteen, should return with her to attend Miss Applegarth's school. Father was being transferred from Helvoirt to a new church at Etten in October, and the move would have disrupted Wil's schooling. Going to Welwyn would also give Wil the opportunity to improve her English. Although it was unusual for girls to travel abroad without their parents at such an early age, the Van Goghs were a cosmopolitan family and their children were given considerable freedom.

The two sisters set off together for Welwyn, arriving on 15 August. Anna wrote back to their parents: 'Happily we arrived this morning at 10 o'clock. The journey at sea was terrible. Wil was also rather seasick, but now everything is behind us. We have rested for a short time on our beds and feel quite refreshed again . . . Wil is very cheerful and tries to speak English . . . To her delight she has found a sweet little kitten. Miss Applegarth is very pleased with the picture *The Little Knitter* and says you couldn't have pleased her more than with

26. A page from Vincent's scrap book, which he filled with his favourite prints. Among them is a Bonington, which he had hung in his bedroom in Paris. The original picture is called *Near Boulogne*, but Vincent gave it his own title, reflecting his personal concern with man's path through life. *'I will tell you what engravings I have on the wall . . . Bonington*, A Road' – Vincent to Theo, 6 July 1875.[15]

a present like that.'[7]

Once Vincent was told that his stay in Paris was being extended, he searched for more permanent accommodation. At the beginning of July he found new lodgings close to Goupil's gallery and printing works, which were at 9 rue Chaptal. 'I have taken a little room in Montmartre which I am sure you would like. It is small, but it overlooks a little garden full of ivy and wild vines,' Vincent told Theo.[8] Montmartre was then still a rural village, with vineyards and windmills, although the city was already encroaching up the hill and dancehalls and open-air cafés were turning the area into a popular entertainment centre.

Vincent's parents were disappointed that he had been unable to return for the summer holiday. They were worried about their son's growing religious fervour, which seemed to be a reaction to his depression. On 8 July, Father wrote to Theo, pointing out that 'melancholy can be dangerous and giving in to it is not very good for generating energy.'[9] Vincent's beliefs were reflected in his letters to Theo, which were no longer friendly communications between brothers, but brief and authoritarian instructions, full of Biblical exhortations.

'You too must go to church every Sunday; even if the sermon is not so good, it is better to go,' he told Theo on 13 August.[10] A month later he actually returned one of Theo's letters, rudely scribbling on the back: 'Do not read Michelet any longer or *any* other book (except the Bible), until we have seen each other at Christmas.'[11] To Theo, this must have seemed confusing

a

advice, because it had been his elder brother who had originally encouraged him to read the philosopher Michelet. Vincent soon went even further, and on 11 October he asked: 'Have you done as I suggested and destroyed your books by Michelet, Renan, etc?'. He paraphrased a verse from Proverbs: 'If thou hast found honey, look to it that thou eatest not too much of it, that it may become loathsome.'[12] These books were strong 'food', Vincent believed, and dangerous unless approached with caution.

Despite his religious puritanism, Vincent continued to derive great pleasure from art. Paris was the capital of the art world, and as well as the commercial galleries, there were the Louvre's Old Masters and the Luxembourg's contemporary art. His favourite French artist was Millet, the painter of peasants who had died earlier that year on 17 January 1875. When a major collection of Millet's pictures was auctioned in Paris in June, Vincent reported that 'when I entered the hall of the Hôtel Drouot, where they were exhibited, I felt like saying, "Take off your shoes, for the place where you are standing is Holy Ground".'[13] On his bedroom wall, Vincent hung engravings of Millet's *Four Hours of the Day*, showing peasants going to work (*Morning*), midday siesta (*Noon*), the farmer preparing to leave the fields (*Twilight*) and the family around their lamp at home (*Night*). Vincent drew copies of Millet's work in the Borinage in 1880 and in Etten the following year. Even more important, it was Millet's images which were to strongly influence his own paintings of peasants. Nearly fifteen years after his stay in Paris, at the asylum in Saint-Rémy, Vincent painted

27. Vincent's sketch and Guiseppe de Nittis' painting of the Houses of Parliament. De Nittis was an Italian painter of city life, living in London. His Westminster scene had been completed early in 1875 and Vincent saw it at Goupil's in Paris, triggering off memories of England. *'A few days ago we received a picture by De Nittis, a view of London on a rainy day, including Westminster Bridge and the Houses of Parliament. I used to pass Westminster Bridge every morning and every evening, and I know how it looks when the sun sets behind Westminster Abbey and the Houses of Parliament, and how it looks early in the morning, and in winter in snow and fog. When I saw the picture I felt how much I had loved London.'* – Vincent to Theo, 24 July 1875.[16]

b

versions of the *Four Hours of the Day*.

Despite Vincent's love for Millet and the Barbizon School, he had little interest in the Impressionists, who were already following in their footsteps. Their first exhibition had been held in Paris in 1874, while Vincent was in London, and it was Claude Monet's *Impression: Sunrise* which then gave its name to the group. By the time of their next exhibition in 1876, Vincent was back in England. Although Vincent lived in Paris at a crucial time when the Impressionists were beginning to make their mark, his artistic tastes at this time were still very conventional.

28. Christina Rossetti's poem, copied at the end of a letter to Theo. *'I know that there are sometimes hard, barren stretches in life's path. Keep courage, lad, sunshine follows after rain; keep hoping for that. Rain and sunshine alternate on "the road that goes uphill all the way, yes, to the very end."'* – Vincent to Theo, 6 October 1875.[17]

Vincent

Does the road go uphill then all the way?
"Yes to the very end".—
"And will the journey take all day long?
"From morn till night, my friend".—

61

My Worthy Englishman

'I was greatly surprised to read that Gladwell was in The Hague . . . I long to see the brown eyes that could sparkle so when we looked at pictures by Michel and others, and talked about "many things". Yes, it would be fine if he came and stayed as long as possible, and I think we should feel that our former friendship was sincere and not superficial; as time goes by one one does not always feel it so strongly, "but it is not dead, but sleepeth," and it would be good to see each other again to wake and bring it to life again.' –
Vincent to Theo, Amsterdam, September 1877.[1]

29. Harry Gladwell, Vincent's closest friend. *'He is as thin as a stick, with two rows of strong teeth, full red lips, glittering eyes, a pair of large, generally red, projecting ears, close-cropped black hair . . . At first everybody laughed at him, even I.'* – Vincent to Theo, 11 October 1875.[16]

VINCENT'S DEPRESSION was lifted by a companion, his first real friend since childhood. Harry Gladwell, an Englishman who also worked for Goupil's in Paris, moved into his lodgings in Montmartre. On 11 October 1875 Vincent told Theo about his new companion: 'A young Englishman, a fellow employee, lives in the same house; he is eighteen years old, the son of an art dealer in London, and will probably enter his father's business later on. He had never been away from home before, and, especially the first week he was here, he was very uncouth; for instance, every morning, afternoon and evening he ate four or six pieces of bread (bread is very cheap here), in addition to several pounds of apples and pears . . . I grew to like him, and now, I assure you, I am very glad to have his company in the evening. He has a wholly ingenuous, unspoiled heart, and is very good at his work.'

'In the morning, usually between five and six, he comes to wake me; we breakfast in my room, and about eight o'clock we go to the office. Lately he has been less greedy at his meals and has begun to collect prints, in which I help him. Yesterday we went together to the Luxembourg, and I showed him the pictures I liked best; and indeed, the simple-minded know many things that the wise do not.'[2] Vincent soon adopted Harry's habit of enjoying French bread. Three days after mocking Gladwell's consumption, he told Theo, 'if sometimes you are very hungry – or rather have an appetite – eat well then . . . Especially bread, boy, "Bread is the staff of life" is a proverb of the English (though they are very fond of meat too, and in

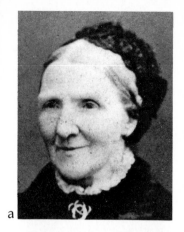

a

c

b

30. Vincent's imaginary 'trip-tych'. *'Take the portraits of our father and mother and the* Farewell *by Brion, and read Heine with those three before you; then you will understand what I mean.'* Vincent to Theo, 13 December 1875.[17]

general take too much of it).'[3]

On 9 November Vincent gave Theo more advice, telling him to rise early in the mornings: 'I do so regularly, and it is a great thing to get used to it; that early hour of dawn is precious, and has become very dear to me. Usually I go to bed very early in the evening.'[4] Six days later he wrote again, saying that 'my worthy Englishman prepares oatmeal every morning; his father sent him twenty-five pounds of it. How I wish you could taste it with us.'

'I am so glad that I met this boy. I have learned from him, and in return I was able to show him a danger which was threatening him. He had never been away from home, and though he did not show it, he had an unhealthy (though noble) longing for his father and his home. It was the kind of longing that belongs only to God and to heaven. Idolatry is not love. He who loves his parents must follow their footsteps in life. He understands this now clearly; and though there is sadness in his heart he has the courage and eagerness to go forward.'[5]

Harry, who had turned eighteen on 5 October, had joined his father's art gallery in the City of London. The young man was sent to Goupil's in Paris to gain experience and practise his French. But he was lonely, missing his parents badly, and he appreciated Vincent's friendship. Vincent, for his part, welcomed the chance to play a 'fatherly' role towards this lonely youth.

Sunday was their favourite day, when they would study the Bible together, attend church, visit museums and see friends.

Both of them read avidly, and Harry interested Vincent in English authors. This led to a curious reversal of the young Dutchman's reading habits. In London Vincent had often read French literature, while in Paris he concentrated on English texts. He particularly loved Dickens, and read many of his books during this period.

Among his other favourite novelists was George Eliot (the pen-name of Mary Evans), particularly her *Scenes of Clerical Life*. The third part of the book, 'Janet's Repentance', had a special meaning for Vincent and he outlined the plot to Theo: 'It is the story of a clergyman who lived chiefly among the inhabitants of the squalid streets of a town . . . For his dinner he usually had nothing but underdone mutton and watery potatoes. He died at the age of thirty-four. During his long illness he was nursed by a woman who had been a drunkard, but by his teaching, and leaning as it were on him, [she] had conquered her weakness and found rest for her soul.'[6] A still more important Eliot book for Vincent was *Felix Holt, The Radical*. In January 1876 he sent Theo a copy, suggesting he read it and then pass it on to their parents. 'It is a book that impressed me very much,' Vincent explained.[7]

Vincent also liked Edward Bulwer-Lytton, a novelist who had died two years earlier. Vincent's Aunt Cornelia, the wife of Uncle Cent, had given him *Kenelm Chillingly*. As he explained to Theo: 'It is really fine – the adventures of a rich Englishman's son who could find no rest or peace in his own sphere and tried to find it among the lower classes. In the end he returned to his own class, but did not regret his experiences.'[8] The other English author who Vincent enjoyed was Thomas Carlyle. In the poetry book he prepared for Theo at the beginning of 1875, he had copied out extracts from *Past and Present*, *Sartor Resartus*, and *On Heroes, Hero-worship and the Heroic in History*.

By the beginning of December, Vincent's mind was turning to the coming holiday. 'I am looking forward to Christmas, aren't you? We shall have a great many things to talk about. It is a pity that Anna cannot come too; I hope she also will have pleasant days. Christmas in England is very interesting, and perhaps Anna will learn to love her surroundings better if she celebrates the holiday there and helps to make things pleasant in the house,' Vincent wrote to Theo on 4 December. He went on: 'My dear Englishman (Gladwell is his name) is also going home for a few days. You can imagine how he longs to go; he has never been away from home before . . . Is it as cold in Holland as it is here? With our little stove, Gladwell and I are very comfortable – morning and evening.'[9]

Five days later, Vincent wrote again, saying that at work he was 'rather busy these days with the inventory and finishing things off before my departure.'[10] The following day he told Theo that he had taken up smoking again, saying that he 'rediscovered in my pipe an old, faithful friend, and now I suppose we shall never part again.'[11] Vincent once more mentioned the coming holiday: 'I am longing for Christmas and am eager to see you, boy, but it will be soon enough now. I think I shall leave here a week from Sunday, in the evening. Try your best to get as long a holiday as possible.'[12]

Despite all the talk of Christmas, something was wrong. Vincent's last letter to Theo before his return contained a bizarre suggestion. He advised his brother to set up three images in front of him. In the centre, there should be a print of Gustave Brion's *Farewell*, a sentimental picture depicting a young man leaving home; his father offers him a final drink, while his mother weeps. On either side of the Brion print, Vincent explained, Theo should place photographs of their father and mother. With these three images before him, Vincent advised his brother to read poems by the German Heinrich Heine, some of which he had copied into Theo's album earlier in the year. Vincent's 'triptych' revealed something of his confused attitude towards his parents.

When Vincent returned to Holland for Christmas, his parents had already moved to Etten, 25 miles west of Helvoirt. It was a small town, but larger than the village of Helvoirt, and the post represented a promotion for Pastor Theodorus. Vincent, who had been so looking forward to seeing their new home, arrived on Christmas Eve and Theo was back from The Hague to welcome him. Except for Anna, who had to stay at Welwyn, all the family gathered for the holiday celebrations.

Theo had to return immediately after Christmas, and Vincent took him to the railway station at nearby Roosendaal. Just before they parted, Vincent again told his younger brother that he sought the company of prostitutes and ten years later Vincent vividly recalled the conversation. 'I still remember seeing you off at the station at Roosendaal in the first year, and that I told you that I hated being alone so much that I preferred being with a bad whore to being alone,' he told Theo.[13]

Vincent's parents found their eldest son increasingly difficult to understand. He was both overwrought and extremely shy. 'He is always so very quiet if he meets somebody,' Mother said.[14] Father felt sorry for him saying that 'there always remains something strange in him . . . It must be a rather lonely life in such a big city. May God guide him.'[15]

65

Sacked

*'I had been with Goupil's for six years. I was rooted there,
and I thought that if I left them, I could look back on six
years of clean work, and that if I presented myself
elsewhere, I might refer to my past with full assurance.
It was by no means so . . . one is simply "somebody out
of work".' –*
Vincent to Theo, Drenthe, autumn 1883.[1]

31. Léon Boussod, the Goupil's director who ended Vincent's career as an art dealer.
'When I saw Mr Boussod again, I asked him if he approved of my being employed in the house for another year, and said that I hoped he had no serious complaints against me. But the latter was indeed the case.' – Vincent to Theo, 10 January 1876.[25]

ON HIS FIRST DAY back at work in Paris, just after the 1876 New Year holiday, Vincent was called into the office of Léon Boussod, the son-in-law of Adolphe Goupil who now ran the company. Vincent explained to Theo that 'something happened to me that did not come quite unexpectedly.' After discussing his future with Mr Boussod, 'in the end he forced me, as it were, to say that I would leave on the first of April, thanking the gentlemen for all that I might have learned.' Vincent seemed to have accepted the situation passively, saying that 'when the apple is ripe, a soft breeze makes it fall from the tree; such was the case here; in a sense I have done things that have been very wrong, and therefore I have but little to say.'[2]

The news was a devasting blow to Vincent's parents. 'We are bitterly sad. We are tired and run down. It gives us a terrible pain . . . What a bitter sorrow for Uncle Cent. What a shame and scandal . . . When you have so many people working for you as in such a firm, there has to be discipline. Everybody has to subject themselves to the wishes of their superiors. Without that, business cannot work,' said Father, who seems to have taken Goupil's side.[3] He told Theo that he had written to Vincent, 'without any reproach, but trying to open his eyes to his own faults.' Father advised Vincent to have another talk with Mr Boussod and try to get him to reconsider his decision or else try to get a few months' leave before making a fresh start with the gallery. Vincent spoke again with Mr Boussod, but without success.

Vincent's family blamed his dismissal on his decision to come home for the holiday. 'One of the grievances against him was that he had gone home to Holland for Christmas and New Year's, the busiest time for business in Paris,' Jo wrote in her

Memoir.[4] But if this was the reason, it is curious that Vincent's letters from early December contain repeated references to coming back to Etten, suggesting that the visit had been arranged in advance. In any case, Vincent had not had a summer holiday when he was far from home, and he was surely entitled to a few days off at Christmas. All this suggests that 'French leave' was not the real reason for his dismissal.

So why then was the apple 'ripe'? Although Vincent had done reasonably well in The Hague and during his first year in London, he found it increasingly difficult to get on with the gallery's customers. This became even more of a problem when Goupil's London branch changed from being simply a distributor of prints to handling paintings, making customer relations more important. Vincent was shy and awkward, lacking tact and finding it difficult to express himself. He also had strong views of his own, and if a customer was about to buy a picture which he did not like, he would often say so. When Vincent had first arrived in England, he had usually meekly kept his thoughts to himself. Gradually he became more outspoken, more rebellious, and Goupil's found this intolerable in an assistant.

Mr Boussod told Vincent: 'You are an honest and active employee, but you set a bad example to the others.'[5] Sacking him must have been difficult because his uncle was still a director of the firm. Mr Boussod and Uncle Cent had discussed the problem, and in the end they agreed that Vincent must go. Had it not been for the family connection, he would probably have been sacked much earlier.

Vincent's dismissal was such a shock that it was not until eight years later that he was able to acknowledge the enormity of what had occurred. Memories of this rejection flooded back, and his letters to Theo then made bitter references to Goupil's. 'At the time more things were left unspoken, than said aloud. If they had acted differently then, if they had said, "We do not understand your behaviour on this or that occasion, explain it," things would have turned out differently,' he told Theo.[6]

Coming just eighteen months after Eugenie's rejection, dismissal was a second disaster, but again Vincent passively accepted his fate. He continued to work out his notice at the gallery, returning to his lodgings every evening with Harry. Jo later wrote that at Goupil's, Vincent 'felt quite out of place. He was more at home in his "cabin", the little room in Montmartre where, morning and evening, he read the Bible with his young friend, Harry Gladwell, than among the mundane Parisian public.'[7]

32. Harry Gladwell's Bible, presented by his grandmother on 8 June 1875, just before he left for Paris. There he and Vincent read the Bible together. *'Every evening we go home together and eat something in my room; the rest of the evening I read aloud, generally from the Bible. We intend to read it all the way through.'* – Vincent to Theo, 11 October 1875.[26]

Three weeks later Vincent suffered a further blow. At the end of January he wrote to Theo, again ascribing feelings to his brother which were troubling him: 'We feel lonely now and then and long for friends and think we should be quite different and happier if we found a friend of whom we might say, "He is the one." But you, too, will begin to learn that there is much self-deception behind this longing; if we yielded too much to it, it would lead us from the road.'

The reason for Vincent's loneliness emerged later in his letter: 'My friend Gladwell is going to move. One of the employees of the printing office has persuaded Gladwell to come and live with him; he had tried to previously. Gladwell has decided to move without thinking it over. I am very sorry he is going; it will probably be soon, toward the end of the month.' Vincent concluded by writing that in 'the last few days we have had a mouse in our "cabin", you know, that is the name of our room. Every evening we put down some bread, and the mouse already knows quite well where to find it.'[8] Harry may have felt it would be unwise to share a room with someone who had just been sacked by their employer. Vincent, in his depressed mood, must also have been difficult company.

Father wrote to Theo on 6 February: 'We think a lot about Vincent and think it is doubly unhappy for him that his English friend has just left him now. He did have some need for somebody to talk to.'[9] Fortunately, the two young men stayed close friends and every Friday evening they got together to read poetry. Among their favourite writers was Henry Longfellow, and Vincent sent Theo a book of his poems in March,

saying he was 'sure the book will become a friend to you'. Longfellow reminded Vincent of England, particularly his 'Tales of a Wayside Inn'. 'I once made a trip on foot to Brighton; I always remember it with pleasure. The inns in England are often so cosy. Longfellow describes it so well,' Vincent told Theo.[10]

Vincent's best friend was soon promoted to his own job. On 15 March, just a fortnight before he left, Vincent announced that 'perhaps Gladwell will come back to his old room; he is to have my place at the gallery.'[11] Eight days later he reported: 'Gladwell has got my place at the gallery and is there already to become familiar with the work before I leave.'[12]

As he was getting ready to leave Paris, Vincent prepared a very special present for an artist friend, the Hague School painter Matthew Maris. When he had been in England, Theo had got to know Maris's work at Goupil's and he once described one of his townscapes of Amsterdam as 'genius'.[13] Maris visited London and Vincent met him occasionally, although Jo claimed that the young gallery assistant was 'too bashful to speak out freely to him and shut all his longings and desires within himself.'[14]

Matthew Maris, whose brothers Jacob and Willem were also important painters, was living in Paris when Vincent was there. Vincent got to know him well and when he left Paris, he filled an album with 65 pages of his favourite poems for the 36-year-old Dutch artist. The poetry album has only been accessible to scholars since it was presented to the Teylers Museum in Haarlem in 1971. The poetry album's most important page is the inside back cover, which contains a small portrait. According to a 1909 letter from Amsterdam dealer Willem van Meurs, he had been told by his friend Maris that the drawing was by Vincent. The identity of the person who Vincent drew has still not been established.

Although Vincent obviously had great admiration for Maris, the feeling was not mutual. Many years later, after being shown some reproductions of Vincent's great paintings, Maris commented: 'If this is meant to be done from nature, then I prefer a photograph a hundred times.'

With Vincent's time at Goupil's approaching the end, his parents encouraged him to stay in the art world. According to the unpublished family correspondence, Mother had told Theo that she hoped Vincent 'will soon find something in one or other museum in London.'[15] Jo later wrote that Father had also suggested that his son consider 'opening up a small art gallery for himself, as Uncle Vincent and Uncle Cor [CM] had done before him; he would have then been able to follow his own

33. Vincent's sketch in the poetry book he filled out for Matthew Maris. *'I think of that fellow so often. Theo, how marvellous his work is . . . what an artist he is.'* – Vincent to Theo, May 1885.[27]

ideas about art and have been no longer obliged to sell pictures which he considered bad.'[16]

Vincent may also have thought of becoming a painter. Eight years after his dismissal, he referred to this idea in a letter to Theo: 'both you and I then thought of becoming painters, but so secretly that we did not dare tell even each other.'[17] Jo also wrote in her *Memoir* that Theo 'had already at that time suggested Vincent's becoming a painter.'[18] Finally, Maris later claimed that Vincent had asked for advice on whether he should become an artist. Maris's response was blunt: 'Go take a rope and hang yourself', meaning that anyone deciding to

become a painter would face a life of starvation and might as well kill themselves there and then.

Vincent wanted to return to England, rather than going back to Holland, and like his sister Anna in the end he decided to seek a job as a teacher. Vincent told Theo that he was 'reading the advertisements in the English papers and have already answered some. Let us hope for success.'[19] By 7 February Vincent had received his first reply. 'They asked if I could teach French, German and drawing, and also asked for my photograph. I answered today; as soon as I hear from them again, I will let you know,' he said.[20] The job was unpaid, in return for board-and-lodging, at a school run by a preacher in the Yorkshire seaside town of Scarborough. Vincent replied, admitting his lack of teaching experience, but saying that he had 'a lot of patience and goodwill.' He was turned down.

On 23 March Vincent reported to Theo: 'Today I answered two advertisements again. I continue to do it, though I get hardly any answers. My time here is drawing to a close.'[21] Religion continued to be his comfort; he read the Bible every night and often went to church. While in Paris he also attended English services, which he described as 'so simple and beautiful'.[22]

Vincent celebrated his twenty-third birthday on 30 March 1876. Harry called on him at 6.30 in the morning and gave him an etching of Théophile Chauvel's *Autumn Landscape*, depicting sheep on a sandy road. Despite his young friend's kindness, it was a miserable birthday; the following day was his last at Goupil's. He had not yet found a job and he had nowhere to go, except to return home. As on the birthday in Brixton two years before, he tried to ignore it. He wrote to his parents speaking 'only about paintings . . . without a word about his birthday or anything else . . . How he loves art, and how deeply he will feel having to take leave of it all. I need not tell you how sad we are, and it must be a great disappointment to you as well,' Mother wrote to Theo.[23]

The following morning brought a welcome surprise, an offer of a teaching job in Ramsgate, Kent. Vincent explained to Theo that he had heard from William Stokes, the schoolmaster. 'He proposed that I go there for a month (without salary); at the end of that time he will decide whether I am fit for the position. You can imagine I am glad to have found something. At all events I have board-and-lodging free . . . Ramsgate is a seaside resort. I read in a book that there are 12,000 inhabitants, but that is all I know about it.'[24] That evening Harry saw Vincent off at the station, bound first for a few days holiday with his parents in Etten.

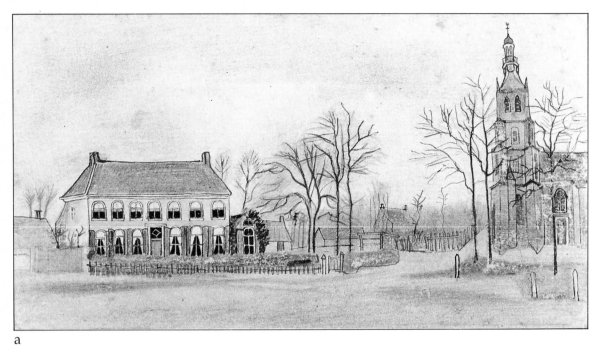

a

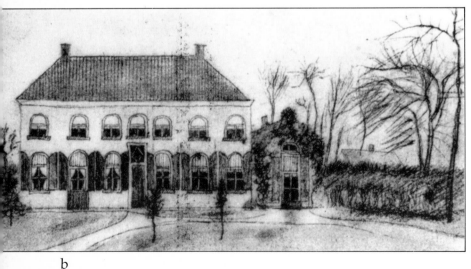

b

34. Two drawings of the vicarage at Etten which Vincent drew in April 1876, just before he left his parents to start a new career in Ramsgate. The vicarage was demolished early this century, but the church still stands. *'These first hours after our parting – which you are spending in church, and I at the station and on the train – how we are longing for each other.'* – Vincent to his parents, 17 April 1876.[28]

c

Ramsgate

*'If there should be no human being that you can love
enough, love the town in which you dwell . . . I love
Paris and London, though I am a child of the pine woods
and of the beach at Ramsgate.' –*
Vincent to Theo, Isleworth, autumn 1876.[1]

ON GOOD FRIDAY 1876, Vincent went to church with his family
at Hoeven, a small village near Etten. Father preached on the
text 'Arise, let us go hence'. That afternoon Vincent left by
train, catching a last glimpse of Father and his youngest bro-
ther Cor waving from the roadside. A few days later, Vincent
wrote a marvellously descriptive letter to his parents, recalling
that although they had parted many times, 'this time there
was more sorrow in it than there used to be . . . Didn't nature
seem to share our feelings, everything looked so grey and
dull.'[2] This is the only letter from Vincent to his parents which
survives from this period. It must have been kept because it
was beautifully written, showing how Vincent could conjure
up a scene in words.

Vincent described how the train passed through Zeven-
bergen, where as a boy of eleven he had attended the boarding
school run by Jan Provily. Embarking on a new career as a
teacher, Vincent had vivid memories of his own time at school:
'I thought of the day you took me there, and I stood on the
steps of Mr Provily's, looking after your carriage on the wet
road; and then of that evening when my father came to visit me
for the first time. And of that first homecoming at Christmas!'
Thoughts of separation from his family were on his mind.

As the train sped on towards Rotterdam, Vincent said good-
bye to his beloved Brabant: 'the sun is disappearing again
behind the grey clouds, but sheds a golden light over the
fields.' He had a long wait at Rotterdam, and thought of going
on to The Hague to see Theo, but decided there was not
enough time.

The following day Vincent caught the steamer for Harwich.
'The last I saw of Holland was a little grey church spire . . . I
stayed on deck till the sun had set. The water was fairly dark
blue with rather high white-crested waves as far as one could
see. The coast had already disappeared from sight. The sky

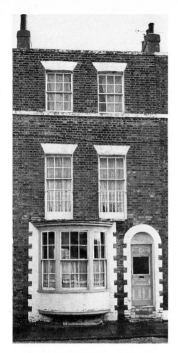

35. The house recently identified as Vincent's home in Ramsgate: 11 Spencer Square. *'There is another assistant teacher seventeen years old. He, four boys and myself sleep in another house near by, where I have a little room that is waiting for some prints on the wall.'* – Vincent to his parents, 17 April 1876.[19]

was one vast light blue, without a single little cloud. And the sunset cast a streak of glittering light on the water. It was indeed a grand and majestic sight, but still the simpler, quieter things touch one much more deeply.'

'At dawn the next morning on the train from Harwich to London it was beautiful to see the black fields and green meadows with sheep and lambs and an occasional thornbush and a few large oak trees with dark twigs and grey moss-covered trunks; the shimmering blue sky with a few stars still, and a bank of grey clouds at the horizon. Before sunrise I had already heard the lark. When we were near the last station before London, the sun rose. The bank of grey clouds had disappeared and there was the sun, as simple and grand as ever I saw it, a real Easter sun. The grass sparkled with dew and night frost.'

Vincent arrived in London on Easter morning at 7 o'clock, leaving soon afterwards for the three and a half hour train journey to Ramsgate. 'It is a beautiful route; for instance, we passed one part that was quite hilly. At the base the hills are covered with scanty grass, and at the top, with oak woods. It reminded me of our dunes. Between the hills was a village with a grey church overgrown with ivy like most of the houses. The orchards were in full bloom and the sky was light blue with grey and white clouds. We also passed Canterbury, a city with many medieval buildings, especially a beautiful cathedral, surrounded by old elm trees. I have often seen pictures of it. You can imagine, I was looking out of the window for Ramsgate a long time before we got there.'

On arrival at Ramsgate, Vincent made his way to the school, in a terraced house at 6 Royal Road, just a hundred yards from the cliff which dominates the harbour. Mr Stokes was away, but his wife Lydia served Easter lunch. 'After dinner we took a walk out on the shore; it was very beautiful. The houses on the shore are mostly built of yellow stone in simple Gothic style, and have gardens full of cedars and other dark ever-greens. There is a harbour full of ships, shut in between stone jetties on which one can walk. And then there is the unspoiled sea, and that is very beautiful,' Vincent told his parents.

That first evening the weather was overcast again. 'We went with the boys to church. On the wall of the church was written: "Lo, I am with you always, even unto the end of the world".'[3] Vincent also sent a short letter to Theo, enclosing a spray of seaweed. His trunk had just been delivered, and he told Theo he was 'going to hang some prints in my room.'[4] Soon after his arrival Vincent made a sketch for his parents. 'We received a letter from Vincent with a nice little drawing of his house,'

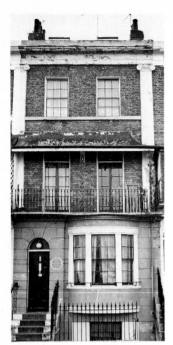

36. The schoolhouse at 6 Royal Road, Ramsgate. Vincent's sketches were done from the bow-window on the first floor. *'There were many bugs at Mr Stokes's, but the view from the school window made one forget them.'* – Vincent to Theo, 7 August 1876.[20]

Mother reported to Theo.[5]

Vincent's lodgings were not in the schoolhouse, and their whereabouts remained a mystery until 1982 when Ruth Brown, who was curious about the young Dutchman's stay in her town, decided to track down his house. She studied the clues in Vincent's letters: the house was near to the school, it was on the same square, and from his window Vincent could see other roofs and the tops of the elm trees. 'By looking in the old rates books I found that Mr Stokes paid rates for both the school in Royal Road and for a house at 11 Spencer Square, just round the corner. I realised that this was probably where Vincent lodged. I knocked on the door and was shown in by the owner, Mark Williams. On the top floor I found a small room with the view, just as Vincent had described it,' Mrs Brown explained.

Mr Stokes returned five days after Vincent's arrival. Vincent then described the 44-year-old schoolmaster to Theo: he is 'a man of medium height, with bald head and whiskers; the boys seem to like yet respect him. A few hours after his homecoming he was playing marbles with them.'[6] Curiously, one fact which Vincent never mentioned in surviving letters is that Mr Stokes was an artist, as had been his father, James Stokes, who had exhibited widely at the British Institution and the Royal Academy until his death in 1865. Professor Ronald Pickvance has discovered that William Stokes had also been a painter and had become a drawing master, before setting up his own general school in Ramsgate.

While Vincent was working for Mr Stokes he did some sketches from the window of 6 Royal Road. The view outside, Vincent believed, was rather more attractive than the house itself. The boys' washroom, he pointed out, had a rotten floor: 'It has six washbasins in which they have to wash themselves; a dim light filters onto the washstand through a window with broken panes. It is a rather melancholy sight.'[7] The main schoolroom was the large room on the ground floor, and from there its bow-window looks out towards the sea. Vincent often sat there, thinking of his beloved Brabant across the sea, and it was there that he twice drew the view for Theo.

Mr Stokes's school had twenty-four boys, aged from ten to fourteen, with some of the boarders coming from as far away as London. Vincent's subjects included French, German, arithmetic and dictation. As he had no experience of teaching, it must have been a challenge. 'Giving them lessons is not hard, but to get the boys to really learn them will be more difficult,' he explained.[8] After classes, he read to the boarders, particularly from his latest favourite book, Elizabeth Wetherell's *The*

37. Drawing from 6 Royal Road. *'I should like to give you a peep through the school window. The house stands in a square (all the houses around it are the same) which is often the case here. In the middle of the square is a large lawn, shut off by iron railings and surrounded by lilac bushes; the boys play there during the recreation hour.'* – Vincent to Theo, 21 April 1876.[21]

38. A second drawing from the schoolroom. The view reminded Vincent of the moment of parting, when he first went to boarding school. *'Enclosed is a little drawing of a view from the school window through which the boys wave goodbye to their parents when they are going back to the station after a visit. None of us will ever forget the view from the window. You ought to have seen it this week when it rained, especially, in the twilight when the lamps were lit and their light was reflected in the wet street. On such days Mr Stokes is sometimes in a bad temper, and when the boys make more noise than he likes, they occasionally have to go without their supper. I wish you could see them looking from the window then, it is rather melancholy . . . The boys made an oil stain on your drawing, please excuse them.'* – Vincent to Theo, 31 May 1876.[22]

39. The view from Royal Road. *'One of my first impressions was that the window of this not-very-large school looks out on the sea . . . The houses near the sea are mostly built of yellow brick in the style of those in the Nassaulaan in The Hague, but they are higher and have gardens full of cedars and other dark evergreens.'* – Vincent to Theo, 17 April 1876.[23]

Wide, Wide World.

On 28 April Vincent congratulated Theo on his nineteenth birthday. 'I am so glad that we have so many things in common, not only childhood memories, but also that you are working for the same house [Goupil's] as I did until a short time ago and know so many people and places that I do and that you have so much love for nature and art,' he said.[9] Three weeks later, on 21 May, Vincent's parents celebrated their silver wedding anniversary. Wil had just returned from Welwyn to join in the celebrations, but both Anna and Vincent could not get away from their teaching jobs in England.

Vincent loved the coast, and once described a walk to nearby Pegwell Bay where the sea was 'as calm as a pond, reflecting the light of the transparent grey sky where the sun was setting.'[10] Two days later there was a violent gale, and Vincent walked along the shore with six of the older boys. 'We saw the lifeboat brought in by a tug, returning from an expedition to a ship that had got stranded on a sandbank far away,' he recalled.[11] *The Happy Return* had been wrecked on the Goodwin Sands, but fortunately the crew were rescued by another ship. A few weeks later Vincent described Ramsgate during a storm as like 'the towns that Albrecht Dürer used to etch.'[12]

Religion was giving Vincent a new strength. On 6 May he sent Theo two English hymnbooks. 'I shall mark a few poems in them. There are so many beautiful ones, and especially when heard often, one grows so fond of them,' he explained.[13] Twelve days later he wrote again, referring to two of the hymns and Eliot's novel *Felix Holt*: 'There is such a longing for religion among the people in the large cities. Many a labourer in a factory or shop has had a pious childhood. But city life sometimes takes away the "Early Dew of Morning". Still, the longing for the "Old, Old Story" remains; whatever is at the heart's core stays there. In one of her novels, Eliot describes the life of factory workers who have formed a small community and hold their services in a chapel in Lantern Yard; she calls it the "Kingdom of God on Earth" – no more and no less. There is something touching about those thousands of people crowding to hear these evangelists.'[14]

Felix Holt was probably Vincent's favourite English book. When he re-read it in April 1884, he told his friend Anton van Rappard: 'There are certain conceptions of life in it that I think are excellent – deep things, said in a guilelessly humorous way; the book is written with great vigour, and various scenes are described in the same way Frank Holl or someone like him would draw them.'[15]

Thirteen years after his stay in England, *Felix Holt* was to

inspire the painting of *Vincent's Bedroom in Arles* [Plate IV]. In October 1889 he told his sister Wil that in the picture he had tried to capture a feeling of simplicity that was unencumbered by the 'refinements of the rich'. Holt, the hero of Eliot's novel, devoted his life to service to the poor, which represented Vincent's own aspirations in his youth. After Vincent painted the bedroom of his 'Yellow House' in Arles, he explained: 'I wanted to achieve an effect of simplicity of the sort one finds described in *Felix Holt*. After being told this you may quickly understand this picture, but it will probably remain ridiculous in the eyes of others who have not been warned.'[16]

In May, Vincent's trial month with Mr Stokes ended and the schoolmaster asked him to stay on, telling him of his plan to transfer the school to Isleworth, a village near London. 'Mr Stokes has told me that he intends to move after the holidays, of course with the whole school. There he will organise his school somewhat differently and perhaps enlarge it,' he wrote to Theo.[17] Vincent, who was earning only board-and-lodging, hoped that at last he would receive a salary. Returning closer to London would also bring him nearer old friends. Soon afterwards Vincent wrote again to Theo, saying that 'these are really very happy days I spend here day by day, but still *it is a happiness and quiet which I do not quite trust* . . . Man is not easily content; first he finds things too easy, and then again he is not contented enough.'[18]

CHAPTER 11

Walking to Welwyn

*'How sweet she [Anna] was with that family at Welwyn,
sharing their happiness and misfortune, and never
withholding any help or comfort . . . I have seen so clearly
how they all loved her.'* –
Vincent to Theo, Etten, 3 April 1877.[1]

ON 12 JUNE 1876 VINCENT left Ramsgate for a one-hundred-mile walk to visit his sister Anna in Welwyn. 'It is a long walk; when I left it was very hot, and it stayed so until the evening, when I arrived in Canterbury. I went still a little farther that same evening, till I arrived at a few large beech and elm trees near a little pond; there I rested for a while.'

'At half past three in the morning the birds began to sing at sight of dawn and I set off again. It was fine to walk then. In the afternoon I arrived at Chatham. There one can see in the distance between partly flooded low-lying meadows, with elm trees here and there, the Thames, full of ships. I believe the weather is always grey. I met a cart which took me a few miles farther, but then the driver went into an inn and I thought he would stay a long time, so I continued on my way. I arrived in the familiar suburbs of London toward evening, and walked to the city along the long, long "roads". I stayed two days in London and have been running from one part to another.'[2]

Vincent had not visited London for a year, except for a few hours changing trains on Easter Sunday. The first night he spent with George Reid, a friend from Goupil's. Five years later, when Theo was visiting London, Vincent had described him as 'a very ordinary man, in that he is not superior in business or in knowledge; but if one knows him somewhat intimately, as a man and a personality, there is none more faithful, more kind-hearted, more sensitive than he. He is so humorous and so witty, and so smart in everyday things, that he is quite a valuable friend in that respect.' He added that of all the people he had known in England, the one he would most like to meet again would be George Reid. 'You must be sure to look him up and tell him that I hope we will renew our former acquaintance, and that I will write to him someday.'[3]

After leaving George Reid's house, Vincent had his most important appointment, a meeting with a pastor from Ken-

80

nington. Vincent had carefully composed a letter, chronicling his life and asking if he would recommend him for a position in the church. He sent a copy to Theo explaining that 'when you read the letter to the clergyman you will perhaps think of me: "He is not so bad after all".'[4] The letter to the Kennington pastor provides a fascinating insight into how Vincent perceived his own life, and it deserves to be quoted in full:

'Reverend Sir: A clergyman's son who, as he has to work for his living, has neither the time nor the money to study at King's College, and who besides is already a few years beyond the age at which one usually enters there and has as yet not even begun preparatory studies in Latin and Greek, would, notwithstanding this, be happy to find a position related to the Church, though the position of a graduate clergyman is beyond his reach.

'My father is a clergyman in a village in Holland. I went to school when I was eleven and stayed till I was sixteen. Then I had to choose a profession, but did not know which. Through the influence of one of my uncles, partner in the firm of Goupil & Co, art dealers and publishers of engravings, I obtained a situation in this business at The Hague. I was employed there for three years. From there I went to London to learn English, and after two years I left London for Paris.

'Compelled by various circumstances, I have left the house of Goupil & Co, and for two months I have been a teacher at Mr Stokes's school in Ramsgate. But as my aim is a situation in connection with the Church, I must look for something else. Though I have not been educated for the Church, perhaps my travels, my experiences in different countries, of mixing with various people, poor and rich, religious and irreligious, of different kinds of work – manual labour and office work – perhaps also my speaking a number of languages, may partly make up for the fact that I have not studied at college.

'But the reason which I would rather give for introducing myself to you is my innate love for the Church and everything connected with it. It may have slumbered now and then, but is always roused again. Also, if I may say so, though with a feeling of great insufficiency and shortcoming, "The love of God and man". And also, when I think of my past life and my father's home in the Dutch village, there comes to me the feeling of "Father, I have sinned against heaven, and before thee, and am no more worthy to be called thy son: make me as one of thy hired servants. Be merciful to me a sinner."

'When I lived in London, I often went to church to hear you and have not forgotten you. Now I ask your recommendation in looking for a position, and also that you keep your fatherly

40. Henry William Gladwell, the father of his friend Harry. *'I stayed at . . . Mr Gladwell's, where they were very, very kind. Mr Gladwell kissed me goodnight that evening and it did me good; may it be given to me in the future to prove my friendship for his son.'* – Vincent to Theo, 17 June 1876.[9]

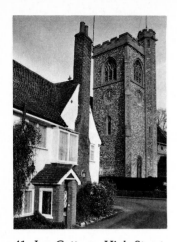

41. Ivy Cottage, High Street, Welwyn, where Anna worked for two years at Miss Applegarth's school. *'When she leaves Welwyn, she will realise how much she has loved it.'* – Vincent to Theo, autumn 1876.[10]

eye on me if I find such a position. I have been left very much to myself, and I think your fatherly eye will do me good. Thanking you in advance for what you may be able to do for me.'[5]

The clergyman promised to try to help the young Dutchman. Vincent then went on to the Gladwell family in Lewisham, at 10 Lee Place, Lee High Street. Harry was still in Paris, but Vincent had last seen him there ten weeks earlier, and he was able to pass on news to his parents. The following day, Vincent had intended to walk through the night to see Anna. 'I wanted to go on to Welwyn that very evening, but they kept me back literally by force because of the pouring rain. However, when it began to let up at about four o'clock in the morning, I set off for Welwyn. First a long walk from one end of the city to the other. In the afternoon at five o'clock I was with our sister and was very glad to see her. She is looking well,' Vincent wrote.[6]

Anna was an assistant at Miss Applegarth's school, and her special subjects were French and music. Thanks to a chance discovery by a local historian in the mid–1950s, the whereabouts of Anna's lodgings have been tracked down. William Johnson had been looking through records in the parish chest of St Mary's when he found a reference to an Anna van Gogh having donated 5 Shillings to church funds in 1876. Her address was given as Rose Cottage, just a hundred yards from the school at Ivy Cottage. Further research has established that this was the home of Miss Applegarth's sister, Catherine Stothard.

42. Rose Cottage, 22 Church Street, Welwyn. Anna boarded at this early sixteenth century cottage. *'You would like her little room as much as I do, with the [prints] Good Friday, Christ in the Garden of Olives, Mater Dolorosa framed in ivy.'* – Vincent to Theo, 17 June 1876.[11]

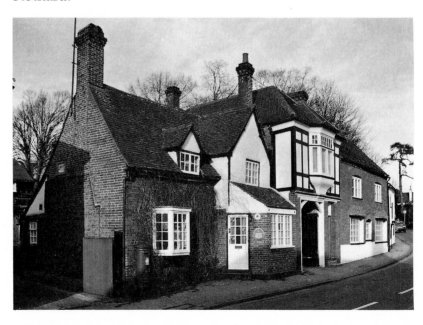

43. St Mary's communion book, with a recently-discovered reference to Vincent's sister Anna. This reveals that she was one of the most regular church attenders, rarely missing a service. *'Today I received a postcard from Anna . . . And thinking of her, I am reminded . . . how she looked forward to Communion, and went to it, and was fortified by it.'* – Vincent to Theo, 3 April 1877.[12]

Vincent arrived with a small present for Anna, some prints of his favourite pictures. 'Vincent is busy showing engravings to the children,' Anna told Theo.[7] Although she had worked in Welwyn for two years, this seems to have been the first occasion that Vincent had visited her there, presumably because relations between them had been strained since the crisis with Eugenie. Now, however, the rift seems to have been healed. When Vincent finally got to Welwyn, his younger sister Wil had already been back in Holland for a month, following her stay at Miss Applegarth's school for the academic year.

After a few days in Welwyn, Vincent set off on foot for Isleworth, ten miles west of London, where Mr Stokes was setting up his new school. Vincent loved these long walks. They gave him time to think by himself, and these walks soon assumed a spiritual dimension, making him focus on his 'road' through life. But these long journeys worried Father, who told Theo: 'I fear that his appearance will suffer and that he will become even less presentable.'[8]

Teacher in Isleworth

'Hampton Court with its avenues of linden trees full of rookeries; Whitehall overgrown with ivy at the back; and the square bordering St James's Park where one can see Westminster Abbey – they are all before me, and the weather and the gloomy atmosphere.' –
Vincent to Theo, Amsterdam, 4 June 1877.[1]

ISLEWORTH was still a village, set in a beautiful spot on the banks of the Thames where the painter Turner had lived sixty years earlier. By the end of June 1876 Vincent was settled at Mr Stokes's new school, at Linkfield House, 183 Twickenham Road. Unfortunately Mr Stokes did not keep his promise of paying a salary after one month's trial. 'Mr Stokes says that he definitely cannot give me any salary because he can get teachers enough for just board-and-lodging, and that is true. But will it be possible for me to continue in this way? I am afraid not; it will be decided soon enough,' Vincent explained to Theo.[2]

Vincent was worried, and on 5 July he wrote to Theo about his ambitions: 'There are no professions in the world other than those of schoolmaster and clergyman, with all that lies between these two – such as missionary, especially a London missionary . . . one has to go around among the labourers and the poor to preach the Bible, and as soon as one has some experience, talk with them, find foreigners who are looking for work or other persons who are in difficulties and try and help them.'[3] The way Vincent described the job, it sounded as if it involved helping people just like himself.

Vincent thought of returning to Holland. He asked Theo to call on Mr Hille, a Bible teacher in The Hague who had instructed him while he was working at Goupil's. 'He took great pains over me. Though I didn't show it, what he told me made an impression on me . . . Tell him that I have become a schoolmaster and am looking out for some situation in connection with the church . . . Give him the enclosed little drawing from me,' he wrote.[4]

Vincent also write to his parents about the possibility of 'becoming a preacher in Latin America'.[5] But in the end he found an opportunity right on his own doorstep. Just a few

44. Holme Court, built in 1715, which became the Revd Thomas Slade-Jones's school. The room where Vincent slept at the back, still over-looks acacia trees, although most of the playground has been replaced by a modern cash-and-carry shop. *'The acacia trees in the playground have almost lost their leaves; I see them through the window in front of my desk – sometimes they stand out dark against the sky, sometimes I see the sun rise red in the mist behind them.'* – Vincent to Theo, October 1876.[16]

houses down the road there was another boys' school which was looking for a teacher and even willing to pay a salary. The Reverend Thomas Slade-Jones promised him £15 a year, plus board-and-lodging.

The Revd Thomas Slade-Jones ran a school at his home at Holme Court, 158 Twickenham Road. Vincent moved there on 3 July 1876, and was given a third-floor room at the back, just above the large dormitory where most of the boys slept. As usual, he immediately decorated the room with prints, includ-ing the Chauvel etching which Harry had given him for his birthday. By this time he had begun to copy out Biblical quotes around the edge of the prints. As a friend later recalled, 'they were always completely spoiled: the white borders were liter-ally covered with quotations . . . which he had scrawled all over them.'[5] He usually then nailed the prints onto the wall, a habit which was not appreciated by his landlords.

Vincent was keen to keep in touch with the friends that he had made while he had been working at Goupil's. Harry Gladwell had come back from Paris for his summer holidays, and on 17 August Vincent went to see him in Lewisham. It took him six hours to walk the fifteen miles, and on arriving he found that tragedy had struck. Susannah, one of Harry's twin sisters, had been killed in a riding accident. Vincent recounted the story to Theo: 'Something very sad happened

85

45. The Revd Thomas Slade-Jones. *'A venerable old man with a big grey beard was the headmaster; he had a special knack of fascinating those boys from the London slums with his stories. In the evening, in the poor light of that schoolroom, all those different faces, and the picturesque figure of that old man, all made a deep impression on me.'* – Vincent's comments to his friend P. Görlitz in 1877.[17]

in his family: his sister, a girl full of life, with dark eyes and hair, seventeen years old, fell from her horse on Blackheath. She was unconscious when they lifted her up, and died five hours later without regaining consciousness . . . They had all just come back from the funeral; it was indeed a house of mourning, and it was good to be with them. I felt a kind of shyness and shame on witnessing that great impressive sorrow.

'I had a long talk with Harry until late in the evening, about all kinds of things, about the Kingdom of God and about the Bible; we walked up and down the station platform, talking thus, and I think we shall never forget those last moments before we said goodbye. We know each other so well: his work was my work; the people he knows there, I know also; his life was my life.' Once again, Vincent was faced with the emotional moment of parting and it was then that all his feelings streamed out.

'From the train the view of London was beautiful, lying below in the dark, St Paul's and other churches in the distance. I went by train to Richmond and walked along the Thames to Isleworth. It was a beautiful walk: to the left, the parks with their large poplars, oaks and elms; to the right, the river, which mirrored the large trees. It was a beautiful, almost solemn evening,' he recalled. The following day Vincent wrote to his brother saying that 'I am still full of what happened yesterday. How I wished to comfort that father, but I was embarrassed before him; to the son I could speak. There was something holy in that house.'[6]

Once term started in September, Vincent was very busy. In the morning, he taught the boys and in the afternoons he often looked after the Slade-Jones's children, an eleven-year-old son and five younger daughters. When evening came, Vincent put the boarders to bed and read them his favourite stories, although he complained that they often fell asleep before he finished. 'You see I do not speak without difficulty; how it sounds to English ears, I do not know,' he told Theo.[7] Afterwards, Vincent would retire upstairs to his bedroom to read, study the Bible, copy into his 'sermon book' or write to his family. He too often fell asleep reading the Bible in bed.

Everyone at Holme Court worked hard. On one occasion, Vincent told Theo that a servant had left: 'they do not have an easy life here, and she couldn't stand it any longer.'[8] Nevertheless, Vincent liked the Slade-Jones family, who seem to have been very sympathetic towards the young Dutch teacher.

Vincent felt particularly close to Mrs Annie Slade-Jones. Evidence of their close friendship emerges in an album which has

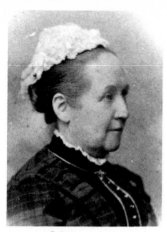

46. Annie Slade-Jones. *'Everywhere in the London streets they sell scented violets, which bloom here twice a year. I bought some for Mrs Jones to make her forget the pipe I smoke now and then, especially late in the evening in the playground, but the tobacco here is a rather gloomy weed.'* – Vincent to Theo, 7 October 1876.[18]

recently has been discovered in which Vincent had copied out some of his favourite texts. Annie's large scrapbook of writings must have been very precious to her, since it was used during her entire adult life from 1855, before her marriage, up to 1923. The book was inherited by her granddaughter Constance Slade-Jones, but when it was realised that it contained extracts written by Vincent it was put on the market and auctioned in 1980.

Vincent wrote out six pages of text in neat tiny handwriting. Curiously, only one of the pages is in English, and the remainder are in French, Dutch and German. These writings present a fascinating insight into the texts which influenced him at the time. The first page, in Dutch, has extracts from four Psalms and eight hymns and poems. This is followed by the one English page, which includes several verses of Corinthians ('Though I speak with the tongues of men and of angels . . .'), three favourite hymns ('Tell me the Old, Old Story', 'O Sacred Head once Wounded' and 'Tossed with Rough Winds, and Faint with Fear'), along with two Longfellow poems ('The Secret of the Sea' and 'Afternoon in February').

The third page is in German, poetry by Friedrich Rückert and three Psalms. This is followed by a page in French, consisting of extracts from some of Vincent's favourite works: *L'Amour (Les Aspirations de l'Automne)* by French romanticist Jules Michelet, verses from Corinthians ('As sorrowful, yet always rejoicing . . .') and *Le Conscrit* by Flemish novelist Hendrik Conscience.

The fifth page continues with *Le Conscrit* and then has the most intriguing entry of all, an extract which appears to be from a diary. Dated 9 April, it is a description of Paris in the evening, when the city is at its most beautiful. Work is finished, and the people have come out on the streets to enjoy themselves. The entry concludes: 'I enjoy sharing this hour of celebration, not to mix with common cheerfulness but to observe it. If other people's happiness sours jealous hearts, it invigorates submissive hearts, it is the ray of sunshine that blossoms out those beautiful flowers named *confidence* and *hope*.'

Could this be a fragment of a long-lost diary kept by Vincent? The date 9 April is inconclusive: Vincent had been in Paris six months earlier, leaving on 31 March, but he could still have written up his impressions of his departure from Paris while he was staying with his parents in Etten. The author shares many of Vincent's attitudes: he was an 'outsider'. However, this could mean it was simply a text which struck a responsive chord in him.

9 Avril. Les belles soirées sont revenues; les arbres commencent à développer leurs bourgeons; les hyacinthes, les jonquilles, les violettes et les lilas, parfument les aventures des bouquetières; la foule a repris l'air du soir. C'est l'heure où Paris se montre dans toute sa beauté. Pendant la journée, la plaine des façades fatigue l'œil par sa blancheur monotone, les chariots pesamment chargés font trembler les pavés sur leurs roues colossales, la foule empressée se croise et se heurte, uniquement occupée de ne point manquer l'instant des affaires; l'aspect de la ville entière a quelque chose d'âpre, d'inquiet et de haletant; mais dès que les étoiles se lèvent, tout change; les blanches maisons s'éteignent dans une ombre vaporeuse; on n'entend plus que le roulement des voitures qui courent à quelque fête, on dirait que partout l'on songe aux joyeux; le travail a fait place aux loisirs. Maintenant chacun respire de cette course insensée à travers les occupations du jour; ce qui reste de force est donné au loisir. Voici les bals qui éclairent leurs péristyles, les spectacles qui s'ouvrent, les boutiques de friandises qui se dressent le long des promenades, les errеurs de gourmands qui font briller leur lanterne. Paris a décidément déposé sa plume, le mètre et le tablier; après la journée livrée au travail, il veut la soirée pour jouir, comme les mailles de Thile, il a remis au lendemain les affaires sérieuses. J'aime à partager cette heure de fête, non pour me mêler à la gaîté commune, mais pour la contempler. Si la joie des autres orgueil écrivеurs, jalou elle fortifie les cœurs soumis, c'est le rayon de soleil qui fait épanouir ces deux belles fleurs qu'on nomme _la confiance_ et _l'espoir_. —

47. Extract in Annie Slade-Jones's album, including Vincent's intriguing entry in French which could be a fragment of a long-lost diary. '9 April. The beautiful evenings are back. The trees have begun unfolding their buds; the hyacinths, the daffodils, the violets and the lilacs scent the stalls of the flower-girls. The crowd has begun to walk alongside the quays, on the boulevards. After dinner, I also went down from my attic room for a breath of evening air. That is the time when Paris exhibits all its beauty.' – Vincent's text in Annie Slade-Jones's album, autumn 1876.[19]

The last page which Vincent copied out is also in French, verses from Psalms and Proverbs and extracts from the writer Emile Souvestre. On the following page someone has pasted a print of Christ in the Garden of Gethsemane. This was a subject which had a special meaning for Vincent, and although he later painted copies of religious works by other artists, the only original religious pictures he ever painted were of Gethsemane. He did two versions in 1888, in Arles, both of which he destroyed.

The writings which Vincent lovingly copied out into Annie's book are more evidence of his growing religious commitment. He still hoped to become an evangelist, and he told Theo about another trip he had made on 23 September to meet the Kennington pastor: 'I left here early at four o'clock in the morning. It was beautiful in the park here, with the dark avenues of elm trees, the wet road through it, and a grey rainy sky above it all; in the distance there was a thunderstorm. At daybreak I was in Hyde Park; the leaves were already falling from the trees and the virginia creeper was beautifully red against the houses, and there was a fog. At seven o'clock I was in Kennington, and rested a little in a church where I used to go so many Sunday mornings.' There he met the priest he had approached earlier, who told him: 'The clergymen in seaports like Liverpool and Hull are often in need of assistants who can speak several languages, to work among the sailors and foreigners and also to visit the sick; some salary is attached to such a position.'[9]

Once again, an opportunity emerged close at hand. The Revd Thomas Slade-Jones not only ran a school, but he was also a Congregational minister, with a church at Turnham Green, three miles away. His 'tabernacle' in Chiswick High Road had been opened in September 1875, just a year before Vincent's arrival. When the minister realised the extent of Vincent's evangelical commitment, he suggested that the young Dutchman could begin helping at the church Sunday

I see the lights of the village
Gleam through the rain and the mist
And a feeling of sadness comes o'er me
That my soul cannot resist
A feeling of sadness and longing
That is not akin to pain
And resembles sorrow only
As the mist resembles the rain

Come read to me some poem
Some simple and heartfelt lay
That shall soothe this restless feeling
And banish the thoughts of day

Not from the grand old masters
Not from the bards sublime
Whose distant footsteps echo
Through the corridors of time

Read from some humbler poet
Whose songs gushed from his heart
As showers from the clouds of summer
Or tears from the eyelids start

Who through long days of labour
And nights devoid of ease
Still heard in their soul the music
Of wonderful melodies

Such songs have power to quiet
The restless pulse of care
And come like the benediction
That follows after prayer

EXAMINATION.

DICTATION.

Name of School

Name of Pupil

Number on Schedule

Standard

48. Letter to Theo written on school examination paper, which includes Longfellow's poem 'I see the lights of the village' and ends with a plea. *'Boy, may God unite us more and more and make us true brothers.'* – Vincent to Theo, 3 October 1876.[20]

49. The Gladwell shop, a watercolour by Thomas Dibdin. The company, probably the longest-established art dealer in Britain, was set up in the mid-eighteenth century and was run by the family until Harry's son Algernon sold it in 1951. The business still operates in the City, from 69 Queen Victoria Street. *'I went to see Mr Gladwell and to St Paul's.'* – Vincent to Theo, 7 October 1876.[21]

school.

'I shall not have to teach so much in the future, but may work more in his parish, visiting the people, talking with them,' Vincent told Theo on 7 October.[10] Soon afterwards, he helped a visiting clergyman from Leicester who lectured on the Reformation with lantern slides of paintings. 'I have already seen some of the pictures, they are in the style of Holbein – you know many painters and graphic artists here work in that style,' Vincent told Theo, referring to the Pre-Raphaelites.[11]

On 7 October the Revd Thomas Slade-Jones sent Vincent to

50. Houses at Isleworth, probably sent to Theo with Vincent's letter of 5 July 1876. *'A little village on the Thames about three hours from London.'* – Vincent to Theo, 28 April 1876.[22]

collect school fees from parents in London. He reached the West End just before six in the evening when the streets were crowded. There he met two of his friends from Goupil's, George Reid and J. Richardson. After catching up with news of Goupil's, Vincent visited Henry Wallis's French Gallery at 120 Pall Mall and then called on Elbert van Wisselingh, who worked at Daniel Cottier's gallery at 8 Pall Mall. Van Wisselingh was a former trainee manager at Goupil's in Paris and a close friend of Matthew Maris, who had been kind to Vincent. 'I always found much that was attractive in him, and he knows many things, and has original and correct sentiments in things of art; in short, he is a man of character,' Vincent recalled seven years later.[12] Both Wallis and Van Wisselingh were to become important dealers for the Hague School painters.

Vincent called at Mr Gladwell's shop and continued to the East End to collect the school fees. 'The suburbs of London have a peculiar charm; between the little houses and gardens there are open spots covered with grass and generally with a church or school or workhouse in the middle among the trees and shrubs. It can be so beautiful there when the sun is setting red in the thin evening mist. Yesterday evening it was like that,' he wrote.

On his return, Vincent walked through the City and caught a bus near the Strand part of the way home to Isleworth, walking the last few miles. 'I passed Mr Jones's little church and saw another one in the distance, with a light still burning at that hour; I entered and found it to be a very beautiful little Catholic church where a few women were praying,' he told Theo. Continuing through Syon Park, he saw 'far away the lights of Isleworth and the church with the ivy, and the church-yard with the weeping willows on the banks of the Thames.'[13]

Vincent loved walking along the Thames. On one occasion he described a scene under 'a sky such as Ruysdael or Constable would have painted.'[14] He also visited Hampton Court, four miles away. He sent Theo a rook feather and once more he linked nature and art, telling Theo: 'Last week I was at Hampton Court to see the beautiful gardens and long avenues of chestnut and lime-trees, where many crows and rooks have their nest, and also to see the palace and the pictures. Among other things there are many portraits by Holbein which are very beautiful; two splendid Rembrandts (the portrait of his wife and of a rabbi); beautiful Italian portraits by Bellini, Titian; a picture by Leonardo da Vinci; cartoons by Mantegna; a beautiful picture by S. Ruysdael; a still-life of fruit by Cuyp, etc. I wish you had been there with me; it was a pleasure to see pictures again.'[15]

CHAPTER 13

The First Sermon

*'In our family, which is a Christian family in every sense,
there has always been, from generation to generation,
one who preached the Gospel.'* –
Vincent to Theo, Dordrecht, 22 March 1877.[1]

VINCENT'S FIRST SERMON was inspired by a painting which
until recently was thought to have disappeared. Boughton's
picture of pilgrims provided an image which was to dominate
the thoughts of the young Dutchman during his last year in
England.

By the autumn of 1876 Vincent had developed an evangelical
fervour. On 10 November he told Theo that he was becoming
more involved with Turnham Green Congregational Church,
now that a new assistant had joined the Revd Thomas Slade-
Jones's school. The young teacher 'has never been away from
home before, and it will not be easy for him in the beginning,'
Vincent explained.[2] Two days later, on 'a really English rainy
day', Vincent had taken Sunday school at Turnham Green, and
had gone on for afternoon tea with the sexton.[3] The following
Sunday, the autumn weather was much more pleasant. 'It was
so beautiful on the road to Turnham Green – the chestnut trees
and the clear blue sky and the morning sun mirrored in the
water of the Thames; the grass was sparkling green and one
heard the sound of church bells all around,' he told Theo.[4]

Thanks to an accidental discovery more information has
emerged about Vincent's work at Turnham Green. During the
exceptionally cold winter of 1963, the church's pipes froze and
burst. 'We had to empty all the cupboards and found piles of
records. I looked through one of them and found references
to Vincent van Gogh,' according to the former minister the
Revd John Taylor.

The Sunday school minutes for 19 November 1876 record
that Turnham Green teachers' meeting accepted 'Mr Vincent
van Gof' as a co-worker. It was also decided that 'we ought
to have a service for the young, on some evening, so that the
influence gained by the teachers on the scholars might be
strengthened.' Vincent's own account of the problem also sur-
vives. 'There are children enough, but the difficulty is to get
them together regularly,' he told Theo.[5] Vincent was annoyed

51. Minutes of Turnham Green teachers' meeting of 19 November 1876, agreeing that 'Mr Vincent van Gof [sic] be accepted as a co-worker'. *'In the future I shall work more at Turnham Green.'* – Vincent to Theo, 10 November 1876.[13]

that foreigners always misspelt or mispronounced his surname, and he therefore much preferred them to use his Christian name.

At the next teachers' meeting, a fortnight later, it was 'proposed by Sims and seconded by Mr Vincent that we hold a children's service every Thursday evening, that the time for commencing be ½ past 6 to close at ½ past 7, & that the secretary prepare a plan & also to get gentlemen to come & address the children.' Another motion decided that 'it be optional with teachers whether they visit their own scholars or Mr Vincent visit them.' Finally, it was agreed that 'Mr Vincent be supplied with all the names & addresses of the scholars in the school & that he go round to each class for particulars of those who require visiting.'

Although Vincent began work with the Congregationalists, he actually gave his first sermon at a Methodist church (which led Jo to claim incorrectly that the Revd Thomas Slade-Jones was a Methodist). Although it was somewhat unusual to attend churches of different denominations, Congregationalism and Methodism were doctrinally similar (the Congregationalists merged with the Presbyterian Church of England in

52. Kew Road Methodist church, at the corner of Evelyn Road. The church was opened in 1871, and it was there that Vincent preached his first sermon. The present building dates from 1937. *'It is a delightful thought that in the future wherever I go, I shall preach the Gospel . . . Your brother was indeed deeply moved when he stood at the foot of the pulpit and bowed his head and prayed.'* – Vincent to Theo, November 1876.[14]

1972 to form the United Reformed Church). Vincent's ecumenical attitude was summed up in a comment he made several months later to a friend in Holland: 'In every church I see God, and it's all the same to me whether a Protestant pastor or a Roman Catholic priest preaches; it is not really a matter of dogma, but of the spirit of the Gospel, and I find this spirit in all churches.'[6]

Every Monday evening Vincent attended the prayer meeting at the Wesleyan Methodist church in Richmond, where he often spoke. On 2 October Vincent chose the text, 'Nothing pleaseth me but in Jesus Christ, and in Him everything pleaseth me' and a week later it was, 'He has sent me to preach the Gospel to the poor.' Soon afterwards he was invited to deliver the Sunday sermon, probably on 5 November. Vincent was following in the footsteps of two generations of pastors, his father Theodorus and his grandfather Vincent, who had died two years earlier.

Vincent described this very special occasion to Theo: 'It was a clear autumn day and a beautiful walk from here to Richmond along the Thames, in which the great chestnut trees with their load of yellow leaves and the clear blue sky were

mirrored. Through the tops of the trees one could see that part of Richmond which lies on the hill: the houses with their red roofs, uncurtained windows and green gardens; and the grey spire high above them; and below, the long grey bridge with the tall poplars on either side, over which the people passed like little black figures.'[7]

Although delivered with deep conviction, Vincent's sermon was rambling and his Dutch accent must have made it difficult for the congregation to follow. He wrote out a copy of the sermon in English, and sent it to Theo. 'When I was standing in the pulpit, I felt like somebody who, emerging from a dark cave underground, comes back to friendly daylight,' he told Theo.[8]

Vincent's text was Psalm 119, Verse 19. ' "I am a stranger on earth, hide not Thy commandments from me." It is an old belief, and it is a good belief that our life is a pilgrim's progress – that we are strangers on the earth, but that though this may be so, yet we are not alone for our Father is with us. We are pilgrims, our life is a long walk or journey from earth to Heaven.'

Vincent stressed that sorrow is part of life, and can prove to be a blessing in disguise. 'Sorrow is better than joy – and even in mirth the heart is sad – and it is better to go to the house of mourning than to the house of feasts, for by the sadness of the countenance the heart is made better,' he told the congregation. Even death should not be feared. 'We only pass through the earth, we only pass through life, we are strangers and pilgrims on earth.' For Vincent, who was always on the move, never able to settle down, this belief provided real comfort.

Vincent went on to explain: 'Has any one of us forgotten the golden hours of our early days at home, and since we left that home – for many of us have had to leave that home and to earn their living and make their way in the world . . . I still feel that feeling of eternal youth and enthusiasm wherewith I went to God, saying: "I will be a Christian too." But with the sorrow that man faces, often the love of Christ may sleep in us but it is not dead and God can revive it in us.'

The most interesting passage occurred towards the end of the sermon. Vincent described one of his favourite paintings by Boughton, telling the congregation: 'Our life is a pilgrim's progress. I once saw a very beautiful picture: it was a landscape at evening. In the distance on the right-hand side a row of hills appeared blue in the evening mist. Above those hills the splendour of the sunset, the grey clouds with their linings of silver and gold and purple. The landscape is a plain or heath

Our life is a pilgrim's progress. I once saw a very beautiful picture; it was a landscape at evening. In the distance on the right hand side a row of hills appearing blue in the evening mist. Above those hills the splendour of the sunset the grey clouds with their linings of silver and gold and purple. The landscape is a plain or heath covered with grass and heather, here and there the white stem of a birch tree and its yellow leaves, for it was in Autumn. Through the landscape a road leads to a high mountain far far away, on the top of that mountain a city whereon the setting sun casts a glory. On the road walks a pilgrim staff in hand. He has been walking for a good long while already and he is very tired. And now he meets a woman ~~in black~~, a figure in black that makes one think of St Paul's word. As being sorrowful yet always rejoicing. That Angel of God has been placed there to encourage the pilgrims and to answer their questions:

53. An extract from Vincent's first sermon. *'Theo, your brother has preached for the first time, last Sunday, in God's dwelling, of which it is written, "In this place, I will give peace." Enclosed a copy of what I said.'* – Vincent to Theo, early November 1876.[15]

covered with grass and its yellow leaves, for it was in autumn. Through the landscape a road leads to a high mountain far, far away, on the top of that mountain is a city whereon the setting sun casts a glory.'

'On the road walks a pilgrim, staff in hand. He has been walking for a good long while already and he is very tired. And now he meets a woman, or figure in black, that makes one think of St Paul's words: "As being sorrowful yet always rejoicing". That Angel of God has been placed there to encourage the pilgrims and to answer their questions.' Vincent then quoted from his favourite poem by Christina Rossetti: 'Does the road go uphill all the way? Yes to the very end. And the journey takes all day long? From morn till night my friend.' Vincent concluded: 'The pilgrim goes on sorrowful yet always rejoicing – sorrowful because it is so far off and the road so long. Hopeful as he looks up to the eternal city far away, resplendent in the evening glow.'[9]

At last it has proved possible to identify 'The Pilgrim's Progress', the Boughton painting which inspired Vincent's sermon. The picture had 'disappeared' until art historian Professor Pickvance recently spotted it hanging unrecognised in a Bond Street gallery. Painted for the Duke of Buckingham, Vincent must have seen it when it was shown at the Royal Academy's 1874 summer exhibition. It is a large work, with a different and rather more cumbersome title, *God Speed! Pilgrims Setting out for Canterbury; Time of Chaucer.*

54. Boughton's painting *God Speed!*, which inspired Vincent's first sermon. *'It is toward evening. A sandy path leads over the hills to a mountain, on the top of which is the Holy City, lit by the red sun setting behind the grey evening clouds. On the road is a pilgrim'* – Vincent to Theo, 26 August 1876.[16]

The Duke auctioned *God Speed!* in 1889 at Christie's, where it fetched £162, and seven years later it was bought by an American collector and donated to the Layton Art Center in Milwaukee. No one realised that the Milwaukee painting was the one that had inspired Vincent's sermon. Because Boughton's sentimental style went out of fashion, it was sold in 1960, ultimately ending up at the Fine Art Society's gallery in London twenty-five years later.

It is fascinating to compare Boughton's painting with Vincent's own description. The young woman who greets the pilgrim is wearing a light coloured tunic, and is hardly a 'figure in black' as Vincent claims (although one of the two pilgrims has dark clothes). The picture's budding vegetation suggests spring, although Vincent describes the heath as being covered with 'yellow leaves, for it was in autumn'. Vincent's description of the sky, with 'the splendour of the sunset, the grey clouds with their linings of silver and gold and purple' gives a grander impression than the painting's rather drab sky. Vincent talks of 'a high mountain far, far away, on the top of that

mountain is a city whereon the setting sun casts a glory', whereas the small town sits on a hill, rather than an imposing mountain, and the absence of a visible setting sun makes it difficult to conclude that it is an evening scene.

Despite the differences, both in title and in content, there is no doubt that Vincent's 'Pilgrim's Progress' is indeed Boughton's *God Speed!*. There is no record of Boughton ever having painted a picture with the title that Vincent gave and none of his other paintings portray a similar scene. The fact that Vincent visited the Royal Academy's 1874 exhibition, where *God Speed!* was shown, is additional confirmation. Perhaps some of the confusion can be traced back to Vincent having just seen 'a sketch' (probably a print) of the picture at the house of Mr Obach a few weeks before he gave his sermon.[10] Most of the mistakes in his description could have resulted from seeing the picture in black and white, and it was, after all, two years since he had seen the coloured original.

Vincent transformed *God Speed!* into a vivid metaphor of life's journey. In doing so, he altered not only visual details, but even the literary source. He renamed the picture 'The Pilgrim's Progress', after John Bunyan's allegory, which he so admired. 'If you ever have an opportunity to read Bunyan's *Pilgrim's Progress*, you will find it greatly worth while,' Vincent had told Theo a few days after his sermon.[11] However, in ascribing Boughton's inspiration to Bunyan, Vincent missed the literary allusion which was intended: Chaucer's pilgrims setting off on the long walk to Canterbury. The key to Vincent's interpretation of Boughton's painting is contained in a remark he made to Theo: 'Truly, it is not a picture but an inspiration.'[12] Boughton had inspired Vincent, who in turn 'painted' his own version of *God Speed!*

Homecoming

> *'When I think of my own experience, when I think of how my working for some years at Goupil & Co ended in my being drawn very strongly toward home, when I think how there followed for me an absolutely bewildering crisis which soon left me entirely alone,* and how everything and everybody *I had formerly relied upon changed completely, and left me high and dry. When I think of those melancholy times, I am so afraid.'* –
> Vincent to Theo, Nuenen, late 1885.[1]

VINCENT RETURNED to Hackford Road on 10 November 1876 on what proved to be his last visit to London. 'I left here at four o'clock in the morning, and at half past six was in Hyde Park. There the dew was lying on the grass and the leaves were falling from the trees; in the distance one saw the pale lights of the lamps which had not yet been put out, and the towers of Westminster Abbey and the Houses of Parliament, and the sun rose red in the morning mist,' he told Theo.[2] He then continued to Whitechapel, 'that very poor part which you have read about in Dickens.'[3]

From the East End, he walked back through London to Hackford Road 'to visit Mrs Loyer again, whose birthday was the day before.'[4] The published version of Vincent's letters then inexplicably omits a tantalising sentence: 'Indeed she is a widow with a heart in which the Psalms of David and the chapters of Isaiah are not dead but sleepeth. Her name is written in the Book of Life.' Coming just a fortnight after Vincent's sermon, this suggests that Vincent may have unsuccessfully tried to convert Ursula to his evangelical version of Christianity.

After leaving the Loyers, Vincent called on Mr Obach. He still liked his former Goupil's boss, although he must have bottled up much of the resentment and anger that were to emerge many years later. Vincent continued on to Lewisham for the evening: 'I arrived at the Gladwells at half past three. It was exactly three months since I had been there on that Saturday when their little daughter was buried. I spent about three hours with them, and we shared many thoughts, too many for expression. From there I also wrote to Harry in Paris.

Dit kerkje is een merkwaardig overblijfsel van eene oude Augustijner stichting (Austin friars) minstens reeds dateerende van het jaar 1354 zoo niet reeds een 100 jaar vroeger. Reeds sedert 1550 ingevolge van eene vrijwillige schenking van Eduard VI houdt de Nederduitsche gemeente hier hare godsdienstige samenkomsten.

a

55. Drawing of Austin Friars church, the City of London, and an 1892 photograph. Vincent sketched the church on one of his trips from Isleworth, and the bare trees suggest this was on his visit of 10 November 1876. Although it was bombed in the Second World War, and rebuilt, it is still the Dutch Church. *'This little church is a remarkable remnant of an old Austin Friars foundation dating at least from the year 1354 if not 100 years earlier. Since as long ago as 1550, as a result of a voluntary gift of Edward VI, the Dutch Reformed Parish has held its gatherings here.'* – Vincent's inscription on the drawing, late 1876.[12]

b

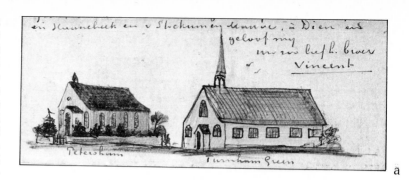

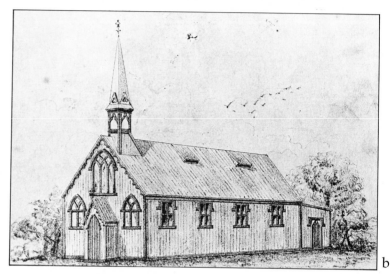

56. Petersham and Turnham Green churches, drawn at the end of a letter to Theo. The foliage on the trees around the Petersham chapel suggests that this sketch was probably not drawn on the spot, since the leaves would have gone by the end of November. Petersham Methodist chapel was built in 1866 and demolished in the early 1890s. When a new church was built at Turnham Green, the 'tabernacle' which Vincent had drawn served as the Sunday school until its demolition in 1909. The Turnham Green sketch was probably based on a newly-discovered drawing by another artist which had been used for a fund-raising appeal in 1875. *'In the morning I had been at the Sunday school in Turnham Green, and after sunset I went from there to Richmond and then to Petersham. Soon it became dark, and I did not know the right way. It was a very muddy road, across a kind of dyke, the slope of which was covered with gnarled elm trees and bushes. At last I saw a light in a little house and climbed and waded through the mud to reach it; there they showed me the right way. But there was a beautiful little wooden church with a kindly light at the end of that dark road.'* – Vincent to Theo, 25 November 1876.[13]

I hope you will meet him someday; it may easily happen that you, too, will go to Paris. At half past ten in the evening I was back here, having used the underground railway part of the way. I had been lucky enough to collect some money for Mr Jones.'[5]

The following day, a Sunday, was devoted to religious pursuits. In the morning he went to Turnham Green Congregational Church and attended the teachers' meeting at which 'Mr Vincent van Gof' was accepted as a co-worker. He then set off for a service at Richmond Methodist church, before finally preaching in the evening at the Methodist chapel at Petersham, a small village one mile south of Richmond. A few days later he sketched the Turnham Green 'tabernacle' and Petersham's 'little wooden church'.

Vincent's last surviving letter from England, probably written shortly after his final visit to London, expresses deep anguish. 'There are hours and days and periods in life when God hides his countenance,' he began, but 'for those who love God, those times, those sad times, are not wholly devoid of God.' He then continued for twelve pages, warning his younger

57. Compilation of all known drawings by Vincent van Gogh, May 1873-December 1876.

Title:	Date:	Medium:	Dimensions:	Drawn for:	Present location:	Letter source:	De la Faille catalogue:	Page:
Copy of Boughton *The Heir*	Summer 1873	-	-	Dutch friend	lost	R19	-	24
Hackford Rd exterior	November 1873	-	-	Parents	lost	U2673	-	26
Hackford Rd interior	November 1873	-	-	Parents	lost	U2673	-	26
Hackford Rd	Spring 1874?	silver pencil, white gouache	11×16	Eugenie Loyer	Amsterdam	-	unlisted	30
View from Hackford Rd	Spring 1874	-	-	Parents	lost	U2710	-	41
Views from Thames Embankment	1873–75	-	-	-	lost	332	-	26
Betsy Tersteeg?	July 1874	pencil	10×15	Betsy Tersteeg	Amsterdam	-	no number	41
Woman, trees & church spire	July 1874	pencil	15×10	Betsy Tersteeg	Amsterdam	no number	-	42
Avenue of trees	July 1874	pencil	15×10	Betsy Tersteeg	Amsterdam	-	no number	43
Trees on horizon	July 1874	pencil	10×15	Betsy Tersteeg	Amsterdam	-	no number	44
House	July 1874	pencil	10×15	Betsy Tersteeg	Amsterdam	-	no number	45
Hackford Rd	July 1874	-	-	Betsy Tersteeg	lost	-	-	38
Steamship	July 1874	-	-	Betsy Tersteeg	lost	-	-	38
Helvoirt church	July 1874	black chalk	21×32	Parents or Wil	NY	-	XVIII	39
Helvoirt view	July 1874	pencil	11×19	Parents or Wil	unknown	-	XIX	39
Helvoirt parsonage	July 1874	-	-	Lies	lost	U2710	-	41
Streatham Common	April 1875	-	-	Theo	lost	25	-	54
Copy of Corot *Ville d'Avray*	April 1875	pencil	4×9	Theo	Amsterdam	25	XX	56
Copy of De Nittis *Westminster*	July 1875	pencil, ink	3×5	Theo	Amsterdam	32	XXIII	60
Portrait	March 1876	pencil	16×11	Matthew Maris	Haarlem	-	unlisted	70
Etten church & parsonage	April 1876	pencil, ink	9×18	Wil	Amsterdam		XXI	72
Etten parsonage	April 1876	pencil, ink	6×12	Wil	unknown	-	XXII	72
View from Royal Rd	April 1876	pencil, ink	7×11	Theo	Amsterdam	62	XXVI	77
View from Royal Rd	May 1876	pencil, ink	6×6	Theo	Amsterdam	67	XXVII	77
Spencer Rd exterior	May 1876	-	-	Parents	lost	U2752	-	75
Isleworth houses	July 1876	pencil, ink	14×15	Theo	Amsterdam	-	XXIV	91
Religious subject?	July 1876	-	-	Hille	lost	71	-	84
Austin Friars church	November 1876	ink	10×15	Father?	Amsterdam	-	XXV	101
Petersham and Turnham Green churches	November 1876	ink	4×10	Theo	Amsterdam	82	XXVIII	102

Notes: Dimensions are given in centimetres, height first and then width. Under location, Amsterdam refers to the Rijksmuseum Vincent van Gogh, NY to a private collection, and Haarlem to the Teylers Museum. For an explanation of the numbering of the letters, see references at end of book. The catalogue numbers are from Jacob de la Faille, *The Works of Vincent van Gogh* (Weidenfeld & Nicolson, 1970), pp. 600–7.

brother that 'the years between twenty and thirty are full of perils of all kinds, full of great perils, aye, perils of sin and death, but also full of God's light and comfort.'

Vincent explained to his brother: 'Who rejoices in grey hairs? Who can look behind it, like Felix Holt did behind the word *failure*? Who is there to see when the first years of life, life of youth and adolescence, life of worldly enjoyment and vanity will perforce wither? . . . Withered wood *does give* more heat, a bright fire and a light, when it is kindled, than green wood.'[6]

Vincent's father, who received similar missives, complained to Theo: 'If only he would learn to become simple as a child, not so overdone and overexcited, bandying around Biblical quotes. We worry more and more and I fear that he may become unequipped for practical life.'[7] He strongly advised Vincent to return home for Christmas. Travelling back to Holland with Anna, who was leaving Welwyn after two and a half years, Vincent had no idea whether he would be returning to Isleworth.

Brother and sister arrived home in Etten on 20 December 1876. Vincent's parents found their twenty-three-year-old son in the depths of despair, moody and depressed, lonely and isolated, bitterly disappointed in love, obsessed by religion, and unsure of what to do next. They advised him to stay in Holland, and Vincent meekly agreed. 'Everything I have undertaken has failed,' he admitted a few months later.[8] Once more Uncle Cent came to the rescue, finding his nephew a job with a bookseller friend.

On New Year's Eve, after Theo had returned to The Hague, Vincent wrote that he had met Mr Braat, whose son Frans worked with him at Goupil's in Paris. Vincent explained that there might be a job at their bookshop in Dordrecht, fifteen miles away: 'Uncle asked Mr Braat if he had a place for me in his business, should I want one. Mr Braat thought so, and said that I should just come and talk it over. So I went there early yesterday morning; I thought I could not let it go by without seeing what it was. We arranged that I should come for a week after New Year's to try it out, and after that we will see. There are many things that make it desirable; being back in Holland near Father and Mother, and also near you and the others. Then the salary would certainly be better that at Mr Jones's, and it is one's duty to think of that because late in life a man needs more. As to the religious work, I still do not give it up.'[9]

The Braat family soon realised that Vincent would not make a bookseller, although there still remained a few signs of his middle class background. 'He always preferred to wear a top hat, a bit of respectability he had brought back from England;

Minutes of Resolutions formed at
Teachers Meeting held February 5/1877.
Mrs Richardson Presided.

Teachers present Misses Stanham Whittingham
Thomas & Thomas. Mr Stembridge Sims & ourbrother
Mrs Jones.

Proposed by Mr Stembridge seconded by Mr Fairbrother
that Mr Vincent be written to & ask for his
resignation, as he had left the country.

58. After Vincent told the Revd Thomas Slade-Jones that he would be staying in Holland, Turnham Green teachers' meeting decided on 5 February 1877 that 'Mr Vincent be written to and asked for his resignation, as he had left the country'. '*I wrote last Sunday to Mr Jones and his wife, telling them that I was not coming back, and unintentionally the letter became rather long – out of the fullness of my heart – I wished them to remember me and asked them "to wrap my recollection in the cloak of charity".*' – Vincent to Theo, 21 January 1877.[14]

but such a hat – you were afraid you might tear its brim off if you took hold of it,' Frans Braat recalled.[10] Vincent proved to have no more enthusiasm for selling books than marketing paintings; his heart was set on becoming an evangelist. As Jo explained in her *Memoir*: 'With the force of despair he clung to religion, in which he tried to satisfy his craving for beauty as well as his longing to live for others. At times he seemed to become intoxicated with the sweet, melodious words of the English texts and hymns, the romantic charm of the little village church, and the lovely, holy atmosphere that enveloped the English service.'[11]

Vincent was not yet ready to channel his emotions into art. Nevertheless, his seven years with Goupil's had helped train his eye and he had begun to draw. It has usually been assumed that Vincent only sketched occasionally, but the first compilation of all the known drawings he did after coming to London, including those which have disappeared, suggests that he drew most of the time. The 29 drawings listed for this period no doubt represent only a small proportion of his total output. Eighteen of the drawings still exist (all but four of which are in the Van Gogh Museum in Amsterdam), and it is astonishing that so many have been saved from this period so long before Vincent was recognised as an artist.

Most of Vincent's drawings are of places he knew well, particularly the houses where he lived. In England, he drew his homes in Brixton and Ramsgate, as well as the vicarages in Helvoirt and Etten. He was to continue this practice, drawing or painting almost every house where he stayed, portraying the exterior, his bedroom or the view from his room 'framed' by the window.

The other subject that fascinated Vincent while he was in London was the motif of a row of trees alongside a road, stretching towards the horizon. In the sketchbook he prepared for Betsy Tersteeg, he drew an avenue of trees, probably a road near Helvoirt. He also loved De Nittis' Westminster, and when he copied it for Theo he exaggerated the height of the trees, emphasising the effect. Lines of trees, disappearing into the distance, were to remain an important motif in many of his later pictures. Vincent painted this theme throughout his life – in The Hague (*A Girl in a Wood*, 1882), in Nuenen (*Lane of Poplars at Sunset*, 1884, see plate I), in Paris (*Road Along the Seine at Asnières*, 1887), in Arles (*Les Alyscamps*, 1888) in Saint-Rémy (*Road Menders in a Lane*) and at the end of his life in Auvers-sur-Oise (*Couple Walking between Rows of Trees*, 1890) (Hulsker catalogue numbers 182, 518, 1254, 1620, 1861 and 2041).

One of the most important unresolved questions about Vincent's stay in England is why he apparently never painted. During these years he used pencil, crayon, ink, and even white gouache, but there are no surviving paintings and no references to painting in his letters. Curiously, however, there is some evidence that Vincent thought of becoming a professional artist after he was sacked by Goupil's. This raises the intriguing possibility that he began to paint – but his pictures are now lost.

PART II

MEMORIES OF ENGLAND

59. *Self-portrait with Swirling Lines*, summer 1889, Saint-Rémy. Vincent was to be strongly influenced by English culture right to the end of his life. *'They are great artists, these Englishmen . . . For me the English black-and-white artists are to art what Dickens is to literature. They have exactly the same sentiment, noble and healthy, and one always returns to them . . . I am organizing my whole life so as to do the things of everyday life that Dickens describes and the artists I've mentioned draw.'* – Vincent to Van Rappard, September 1882.[1]

Evangelist to the Miners

'A few days ago I received a letter from Reverend
Mr Jones of Isleworth in which he writes about building
little wooden churches here in the Borinage . . .
He even speaks of coming here in the autumn to talk it
over; I certainly hope it happens.' –
Vincent to Theo, the Borinage, June 1879.[2]

NINE MONTHS AFTER his return to Holland, on 5 September
1877, Vincent once again saw his 'worthy Englishman'. 'It was
a delightful sensation to hear Gladwell's voice in the hall while
I sat working in my room upstairs, and to see him enter a
moment later, and to shake hands with him,' Vincent told
Theo.[3] Vincent recounted to Harry what had happened since
Isleworth. Bookselling proved unsatisfying, and he had left
Dordrecht in May, convinced that his vocation lay with the
Church. In order to get a good position, it was necessary to
have a degree, and to go to university he needed Latin and
Greek. So he had come to Amsterdam to take private coaching
in the two languages. Father had arranged for him to stay with
Uncle Jan, commandant of the naval dockyard, and when
Harry arrived Vincent was living at their comfortable house at
Grote Kattenburgerstraat 3.

Harry and Vincent talked late into the night. The following
day, they went out together as they had done so often before,
buying books and prints, visiting museums and calling on
friends. Vincent explained to Theo: 'We also spent a great deal
of time in my little study and talked of many things, new and
old. Once more as he sits here beside me, I experience the
same feeling that drew me to him so often – as if he were a
son of the same house and a brother in faith . . . The time
passed only too quickly for me, and I wished that we might
have been together longer; but that was impossible – each of
us must go his different way and continue to do whatever
comes to hand, according to his call. For my part, I am thankful
from the bottom of my heart that it has been given to me to
see him again and to see what first attracted me.'[4]

The visit brought back memories of Goupil's, and soon after-
wards Vincent told Theo that he had received a short note
from Harry on his return to France. 'On a day like this I should

like to walk again with him in the twilight, along the Seine, around Nôtre Dame. Paris is so enchantingly beautiful in autumn, and that spot above all. How pretty the winter chrysanthemums will be in the little gardens in London – they continue to bloom there all winter through,' Vincent wrote.[5] Three months later, Vincent mentioned Harry once again. 'I think it my duty to make sure he hears from me once in a while; I hope he will be able to go to Lewisham at Christmas,' he told Theo, remembering how they had both looked forward to going home for the holiday two years earlier.[6]

While in Amsterdam, Vincent continued to keep up his religious links with English churches. On Sundays, he attended the English Reformed Church in the Begijnhof. 'I love that little church, and probably many a person there has memories of things and places which are known to me,' he told Theo.[7] The church, which still exists, is run jointly by the Church of Scotland and the Dutch Reformed Church.

Vincent also taught at Zion's Chapel, a Sunday school run by the British Society for the Propagation of the Gospel Among the Jews. In February 1878, he explained to Theo: 'At one o'clock I had to be at the Sunday school of an English clergyman, [August] Adler, in the Barndesteeg; he has a small but very neat old church there. However, the school was held in a little room where even at that hour, in the middle of the day, the gaslight had to be turned on. There were perhaps twenty children.'[8] Zion's Chapel has been demolished and Barnde-

61. Eugenie's locket, with photographs of herself and Samuel. The couple married on 10 April 1878, the day of their birthdays. By this time Vincent was devoting his life to the Church. *'I must become a good clergyman who has something to say that is right and may be of use in the world.'* – Vincent to Theo, 3 April 1878.[14]

steeg is now in the centre of Amsterdam's 'red light' district.

Vincent became worried by the contradiction between the academic study of 'dead' languages and teaching the children of the poor. Even a theological degree seemed increasingly irrelevant to his own vision of Christianity. In July 1878 he abandoned his studies in Amsterdam and returned to his parents in Etten. By good fortune, the Revd Thomas Slade-Jones was visiting the Low Countries and was able to help at a crucial moment. They had corresponded regularly since Vincent had left Isleworth, and the Congregational minister was still keen to encourage him in his religious vocation. He suggested that Vincent should apply to a mission training school at Laeken, near Brussels, and proposed that they should go together for an interview.

Father explained to Theo that the interview had been a success: 'It was a happy coincidence that the Reverend Jones, with whom Vincent was in England, accompanied us. He had arrived the Saturday before and stayed with us until Tuesday when he went with us to Brussels. He is a most gentle person who made a good impression on all of us. In Brussels he gave Vincent a good testimony and his presence caused the talk to be mostly in English which afforded Vincent the opportunity to show that he spoke it quickly and well and earned him a compliment. We are now awaiting a letter concerning the time

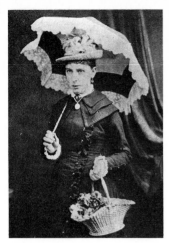

62. Carolyn Arney, whom Harry Gladwell married on 31 May 1879. By this time Vincent and his friend had gone their separate ways, and Harry was becoming a wealthy art dealer. *'We talked about many things, and the gist of it was: Many people arriving at the moment in life when they must make a choice, have chosen for their part "the love of Christ and poverty".'* – Vincent to Theo, 7 September 1877.[15]

and manner when he should start. It does seem that he has a certain vocation for this kind of work, while I have already warned him against its drawbacks – but he still insists.'[9]

Vincent was looking forward his evangelical training: 'We saw the Flemish training school; it has a three-year course, while, as you know, in Holland the study would last for six years more at the least. And they do not even require that you quite finish the course, before you can apply for a place as [an] evangelist. What is wanted is the talent to give popular and attractive lectures to people, more short and interesting than long and learned. So they require less knowledge of ancient languages and less theological study (though everything one knows is an asset), but they value more highly fitness for practical work and the faith that comes from the heart.'[10]

On 22 August 1878 Vincent's sister Anna married Joan van Houten and Vincent stayed on for the wedding in Etten. Immediately afterwards, he left for Laeken, but he failed to qualify for the course at the end of the three-month trial period. He had difficulty in speaking publicly; he was insufficiently 'submissive' and was regarded as a rebel; and his manners were 'poor'. He also paid little attention to his clothes and dressing respectably was part of his past he had left behind him. As he explained, it was wrong to dress to impress. Only a child of fourteen, he said, 'thinks that his dignity and his rank in society oblige him to wear a top hat'.[11]

Vincent headed off on his own, leaving for the Borinage, a poverty-stricken area in the south of Belgium. In January 1879 he found a six-month assignment as an evangelist in the coal mining village of Wasmes. He continued to keep in touch with the Revd Thomas Slade-Jones and in June 1879 the Isleworth clergyman wrote to suggest building 'little wooden churches' in the Borinage. Vincent must have hoped that he might be able to help run one of the new churches. But it never came off, partly because the Revd Thomas Slade-Jones also had pressing tasks at home, particularly the construction of a new stone church at Turnham Green which was finally opened in 1881. Running both a church and a school overworked the Revd Thomas Slade-Jones, and he died on 20 March 1883.

Vincent's own situation worsened, and when his initial six months were up at Wasmes he was dismissed. His superiors felt that he was sacrificing himself too much, and his poverty-stricken condition was regarded as inappropriate for a clergyman. Rejection plunged him into even deeper despair. He moved to the nearby town of Cuesmes, where he laboured as an evangelist without official backing from the church. For a year he lived in abject poverty, but it was difficult to carry the

gospel to the people. His old friends were worried about him, and in July 1879 Mr Tersteeg, his former boss from The Hague, sent him a sketchbook and a box of paints.

The miners of the Borinage ignored him as an eccentric. Vincent found it impossible to communicate the faith which he had first discovered in England. He had turned to religion in the face of his own sorrow, but in the end it just led to further rejection. 'There may be a great fire in our soul, yet no one ever comes to warm himself at it, and the passers-by see only a wisp of smoke coming through the chimney, and go along their way,' he wrote sadly in July 1880.[12]

The Next Love

'Love is something so positive, so strong, so real that it
is as impossible for one who loves to take back that feeling
as it is to take his own life.' –
Vincent to Theo, Etten, 7 November 1881.[1]

As VINCENT'S RELIGIOUS FAITH began to waver he found a new challenge. 'In spite of everything I shall rise again: I will take up my pencil . . . and I will go on with my drawing. From that moment everything has seemed transformed for me,' he told Theo in September 1880.[2] Three weeks later Vincent left the Borinage for Brussels, where he enrolled for classes at the Academy of Fine Art. But despite his initial enthusiasm, the transition from preacher to art student proved difficult. Money was short, and in April 1881 he returned to his parents' home in Etten, where he continued to draw, trying to develop his artistic skills by himself.

It was at Etten that Vincent fell in love for the first time since Eugenie had rejected him seven years earlier. During the summer of 1881 his cousin Cornelia (Kee) Vos had come to stay. Her husband Christoffel, a pastor, had died the previous autumn and the Van Gogh parents thought that a holiday in the countryside would be good for the grieving mother and her eight-year-old son Johannes. Vincent, who had known the Vos family in Amsterdam, began to lavish his affections on Kee. Still feeling the loss of her husband, she was totally oblivious to the effect she was having on her younger cousin. To her, Vincent seemed a well-meaning if somewhat eccentric relative.

One August day, Vincent confessed to Kee that he was in love. Her instant reaction was 'no, never' – she immediately left Etten and rushed home to Amsterdam. For Vincent, this rejection was a terrible shock and he was determined not to react as he had done in Brixton, when he passively retreated into himself. This time he behaved quite differently, being unwilling to even consider rejection. As Vincent explained to Theo, once upon a time he had been 'the man whose little boat capsized when he was twenty years old, and sank'. Now he had come 'to the surface again' and would never allow himself to drown.[3] Vincent was determined to woo Kee,

63. Vincent's version of Millet's *Angelus*, which he drew in Brussels in October 1880. *'That picture by Millet, The Angelus, that is it – that is beauty , that is poetry.'* – Vincent to Theo, January 1874.[8]

64. *'The Bearers of the Burden'*, April 1881, depicting miners' wives carrying coal. This was the first drawing that Vincent titled in English. It was probably inspired by a Boughton painting with the same title which Vincent saw at the Royal Academy in 1875. *'I have sketched . . . "The Bearers of the Burden" . . . You will see, I hope, that I am gradually improving.'* – Vincent to Theo, 12 April 1881.[9]

despite her rebuff.

He wrote to Kee in Amsterdam, but his pleading letters went unanswered. In desperation, he travelled there to speak to her directly, but, on his arrival, Uncle Johannes said that Kee had fled as soon as she had heard that he was there. Vincent's determination reached fever pitch: 'I put my hand in the flame of the lamp and said, "Let me see her for as long as I can keep

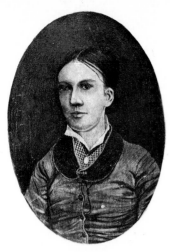

65. A portrait Vincent drew in June 1881 from a photograph of Kee, the cousin he fell in love with. *'To express my feelings for Kee, I said resolutely, "She, and no other". And her "no, never never" was not strong enough to make me give her up.'* – Vincent to Theo, April 1882.[10]

my hand in the flame" . . . They blew out the lamp and said, *"You will not see her."* . . . Then, not at once, but very soon, I felt that love die within me; a void, an infinite void came in its stead.'[4] Vincent never again saw his cousin Kee.

The emptiness created by Kee's final rejection not only killed his love, but also his religious faith. Seven years earlier, after Eugenie's rejection, Vincent had found solace in the Church. This time, he went to the other extreme, rejecting organised Christianity. Vincent was still living at home in Etten, and Father regarded his son's sudden antagonism towards the Church as a personal rebuff. They argued bitterly, and in November 1881 Vincent left home, setting off for The Hague. He returned to the town where twelve years earlier he had started his career with Goupil's.

Rejection by Kee encouraged Vincent to turn to prostitutes. As he explained to Theo: 'It is not the first time that I was unable to resist that feeling of affection, aye, affection and love for those women who are so damned and condemned and despised by the clergymen from the pulpit.'[5] This time, however, he did not face the moral conflict that he had done in London. 'I am no friend of the present Christianity, though its *Founder* was sublime; the present Christianity I know only too well. That icy coldness hypnotised even me in my youth, but I have taken my revenge since. How? By worshipping the love, which they, the theologians, call *sin*, by respecting a whore.'[6]

Within a few weeks of his arrival in The Hague Vincent fell in love for the third and last time in his life, this time with a prostitute. Christina (Sien) Hoornik, who was 32, was struggling to bring up her five-year-old daughter by earning her living on the streets. She was pregnant again, drank heavily and was in poor health and very moody, yet despite her desperate situation – or perhaps because of it – Vincent fell in love. 'I had not forgotten another woman for whom my heart was beating, but she was far away and refused to see me; and this one walked the streets in winter, sick, pregnant, hungry – I couldn't do otherwise,' he explained to Theo.[7]

It was in The Hague that Vincent really began to develop his artistic talents. Although he arrived as a family outcast, he was helped by Anton Mauve, the successful Hague School painter who had married his cousin Jet Carbentus in 1874. It was Mauve who suggested that Vincent should take up painting and gave him instruction. He also introduced him to Weissenbruch, the painter of the *Mill on the Rijkswijk Road*, who encouraged him to persevere. Unfortunately Vincent's relations with Mauve quickly soured and by March 1882 they had broken off contact. Vincent also kept in touch with Ter-

66. *Father*, drawn in July 1881 while Vincent was living at Etten. At the end of the year they had a bitter row. *'I had a violent scene with Father, and it went so far that Father told me I had better leave the house . . . There was much more at the back of it all, including the whole story of what happened this summer between Kee and me. I do not remember ever having been in such a rage in my life, I frankly said that I thought their whole system of religion horrible.'* – Vincent to Theo, December 1881.[11]

steeg, and although there were frequent tensions, the relationship from Vincent's early days at Goupil's was to remain important right up to the end of his life.

After baby Willem was born on 2 July 1882, Sien moved into his flat with the new infant and her daughter. For the first time, Vincent had his own family, complete with two children. Sien was not only his lover, but also his model, the inspiration for his drawing. Although money was short, they were able to survive on payments which Theo sent out of his income from Goupil's. By this time Vincent's behaviour had made him a social outcast. He had first fallen in love with his cousin while she was in mourning. The clergyman's son had then started living with a prostitute – and even talked of marrying her. All this was too much for the Van Gogh family. Only Theo stood by Vincent.

English Illustrators

'More than ten years go, when I was in London, I used to go every week to the show windows of the printing offices of the Graphic *and the* London News *to see the new issues. The impressions I got on the spot were so strong that, notwithstanding all that has happened to me since, the drawings are clear in my mind. Sometimes it seems to me that there is no stretch of time between those days and now.' –*
Vincent to Van Rappard, The Hague, February 1883.[1]

WHEN VINCENT FINALLY DECIDED to become an artist in the early 1880s, the most important influence on him in The Hague was not the great heritage of Dutch painters, but the work of English 'black-and-white' illustrators. Vincent admitted that it was his stay in London which had first kindled his interest in them. 'I learned much about them and their work by seeing a lot of what they did. Without having been in England for a long time it is hardly possible to appreciate them to the full,' he explained.[2]

The best illustrators worked for the weekly magazines, particularly the *Illustrated London News* and the *Graphic*. They would draw directly onto a wood block, with an engraver then cutting away the surface between the lines, leaving the picture in relief. Vincent told Theo about one of the most celebrated of the engravers, Joseph Swain. 'Maybe you know the wood engravings by Swain; he is a clever man, his studio is in such a pleasant part of London, not far from that part of the Strand where the offices of the illustrated papers (the *London News*, *Graphic*, etc) are,' he wrote soon after his return from England.[3]

The *Illustrated London News* had started in 1842, but it had become conservative, both politically and artistically, and in 1869 the rival *Graphic* was established. This new magazine employed a younger generation of artists, who were concerned about social injustice. By the 1870s these illustrators had reached their peak of creativity. 'There is something virile in it – something rugged – which attracts me strongly,' Vincent explained.[4] He liked the way the English illustrators used simple lines, or a 'bold contour', to depict their subjects.[5] The

119

67. Vincent's copy of the Christmas 1882 issue of the *Graphic*, depicting the magazine's illustrators, including Herkomer, Holl and Fildes. Although Vincent greatly admired the *Graphic*, by the 1880s he felt it was losing its best illustrators. *'Look at that group of great artists, and think of foggy London and the bustle in that small workshop.'* – Vincent to Theo, late December 1882.[18]

68. Frank Holl's *The Foundling*, from the *Graphic*, 26 April 1873. It depicts a policeman saving an illegitimate baby abandoned on the Thames Embankment, while the grieving mother is about to jump into the river to kill herself. The mother reminded Vincent of Sien. Vincent had seen the original painting on which Holl's etching had been based at the Royal Academy in 1874 (then entitled *Deserted – A Foundling*). *'If you know the large drawing in the* Graphic *by Frank Holl,* Deserted, *I should say that she resembles the woman in it.'* – Vincent to Theo, mid 1882.[19]

69. Holl, *Gone! – Euston Station,* from the *Graphic,* 19 February 1876. The women have just said goodbye to their husbands, who have left for Liverpool to emigrate and find work. Once more, Vincent found that one of Holl's figures reminded him of Sien. *'The character of the woman I wrote you about is something like that of the principal figure on that sheet – I mean the mother with the baby on her arm . . . I could not give you a better description of her.'* – Vincent to Van Rappard, February 1883.[20]

70. *'The Great Lady,'* April 1882. Vincent's drawing was inspired by Thomas Hood's poem 'The Song of the Shirt', a favourite with English artists. *'There is a poem by Thomas Hood, I think, telling of a rich lady who cannot sleep at night because when she went out to buy a dress during the day, she saw the poor seamstress – pale, consumptive, emaciated – sitting at work in a close room. And now she is conscience-stricken about her wealth, and starts up anxiously in the night. In short, it is the figure of a slender, pale woman, restless in the dark night.'* – Vincent to Theo, April 1882.[21]

The Great Lady

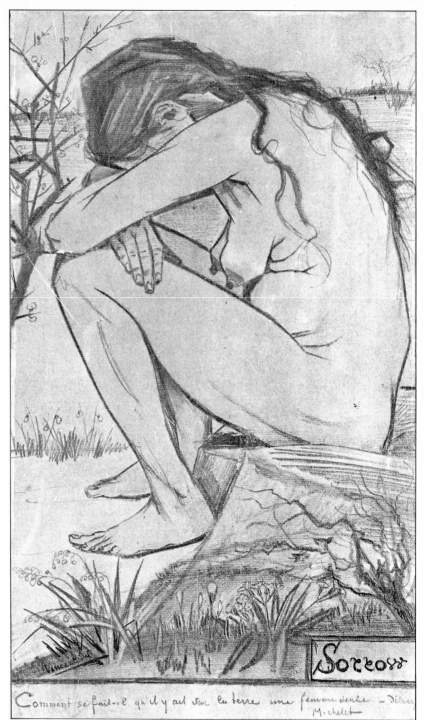

71. 'Sorrow', April 1882. Vincent drew Sien with bold lines, in the style of English illustrators. Underneath the drawing, Vincent copied out one of his favourite quotations from Michelet: 'How is it possible that there could be on earth a woman alone and abandoned'. *'The enclosed is the best figure I have drawn yet . . . I don't always draw this way, but I'm very fond of the English drawings done in this style, so no wonder I tried it.'* – Vincent to Theo, 1882.[22]

72. 'Worn Out', September 1881. Vincent titled his work after a painting by the English artist Thomas Faed. *'It shows an old workman sitting lost in thought, his elbows on his knees, and his hands clasping his head.'* – Vincent to Van Rappard, November 1882.[23]

sentimental style of the images also appealed to him, depicting ordinary working people in a 'social realist' style. 'An artist needn't be a clergyman or a churchwarden, but he certainly must have a warm heart for his fellow men. I think it very noble, for instance, that no winter passed without the *Graphic* doing something to arouse sympathy for the poor,' he said.[6]

Memories of the illustrations Vincent had seen in England had come back to him when he started at the Academy in Brussels. In January 1881 he had reported to Theo: 'I have finished at least a dozen drawings, or rather sketches in pencil and in pen and ink, which seem to me to be somewhat better. They vaguely resemble certain drawings by Lançon, or certain English wood engravings.'[7] The following month he announced he was 'collecting wood engravings again'.[8] It was also at Brussels that he had met his friend Anton van Rappard, and they continued to correspond regularly, exchanging prints and discussing their favourite engravings.

By the time Vincent reached The Hague, the English illustrators dominated his artistic tastes and he began avidly to

123

b

73. 'At Eternity's Gate', November 1882. Vincent's lithograph was inspired by an illustration by Arthur Houghton for Dickens's *Hard Times*. *'In this print I have tried to express . . . the existence of God and eternity.'* – Vincent to Theo, November 1882.[24]

a

74. *Orphan Man Drinking Coffee*, November 1882. Vincent did a series of drawings and lithographs of 'orphan men' (or war veterans), inspired by the way that the English illustrators drew the poor. *'No result of my work could please me better than that ordinary working people would hang such prints in their room or workshop.'* – Vincent to Theo, late 1882.[25]

75. *Fisherman in a Sou'wester*, January 1883. Vincent attempted to emulate the 'Heads of the People' portraits which appeared in the *Graphic*. *'I hope to learn a few more things about the forces of black-and-white from these Graphics . . . What I have been working at especially of late is heads – Heads of the People – fishermen's heads with sou'westers.'* – Vincent to Van Rappard, February 1883.[26]

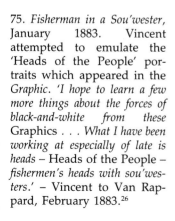

collect back-issues of the English weeklies. 'A collection of sheets like these becomes, in my opinion, a kind of Bible to an artist, in which he reads from time to time to get in a devotional mood,' Vincent explained.[9] He had three favourite illustrators – Frank Holl, Luke Fildes and Hubert Herkomer.

In January 1883 Vincent made his largest purchase of the magazines, an almost complete run of the *Graphic* from the start of publication in 1869 to 1880, which he bought for the bargain price of 19 guilders. He wrote in great excitement to Van Rappard: 'The *Graphics* are now in my possession. I have been looking them over until far into the night.'[10] Vincent went on to ask for advice on whether he should break up the bound volumes by taking out the illustrations, which could then be filed by artist or subject. 'If I cut out the sheets and mount them, they will show up better and I can arrange them according to the artists who did them. But then I mutilate the text . . . I'd also have to spend a lot on mounting board,' he wrote to his friend.[11] In the end, Vincent split up the volumes, pasting the prints on dark card. 'I have finished cutting out and mounting the wood-engravings from the *Graphic*. Now that they are arranged in an orderly manner, they show up ever so much better,' he reported a month later.[12]

The English illustrations proved to be a vital source of inspiration for Vincent's own drawing. 'Every time I feel a little out of sorts, I find in my collection of wood engravings a stimulus to set to work with renewed zest. In all these fellows I see an energy, a determination and a free, healthy, cheerful spirit that animates me. And in their work there is something lofty and dignified – even when they draw a dunghill,' he told Van Rappard.[13] Much of Vincent's own work in The Hague was inspired by these black-and-white artists, particularly his sketches of 'orphan men'.

Vincent wanted to become an illustrator, and he often talked of returning to London. 'If I went . . . to England, if I made every effort, I should certainly have a chance of finding a job . . . Of course, I love to do my best on my drawings, but to present myself at all those publishers' offices – oh, I hate the thought of it!' he had told Theo in December 1882.[14] By the following year, Vincent was talking more confidently: 'I should like to get into contact with the *Graphic* or *London News* in England . . . I should think it advisable to go to London myself with studies and drawings and to visit the managers of the various establishments or, better still, the artists Herkomer, Charles Green, Boughton . . . I don't think it's every day that the managers of magazines find somebody who considers making illustrations his speciality.'[15]

76. *The Soup Kitchen*, March 1883. Vincent's models were Sien (on the right), her six-year-old daughter, her younger sister and her mother holding baby Willem in her arms. His new 'family' reminded him of his favourite Eliot novel. *'When you see this group of people together, can you understand that I feel at home with them? Some time ago I read the following words in Eliot's* Felix Holt, The Radical: *"The people I live among have the same follies and vices as the rich, only they have their own forms of folly and vice." ' –* Vincent to Theo, March 1883.[27]

London became the centre of Vincent's hopes. He even gave English titles to some of his favourite drawings, presumably because he felt it would make them more appealing to British publishers. 'There would be more chance of selling my work, and I also think I could learn a great deal if I came into contact with some artists there. And I can assure you, I should have no lack of subjects there. What beautiful things one could make at those dockyards on the Thames!' he told Theo.[16] A few weeks later he added, 'I sometimes think of England; but I do not know to what extent my work will please the English art lovers . . . in England they are very serious once they start something; whoever catches the public's fancy in England finds faithful friends there.'[17]

Vincent's desire to go to London soon became linked to his unhappiness with Sien. The domestic bliss he hoped for never came. After the birth of her baby, Sien was preoccupied looking after Willem and had little energy for posing. Like Vincent, she was very difficult to live with. Sorrow for Sien's plight and his own loneliness had drawn Vincent towards her, rather than real love, and they never married. Vincent's affection for Sien proved to be little compared to the dreams that he had once had about Eugenie and Kee.

I. *Lane of Poplars at Sunset,* showing Vincent's 'avenue of trees' stretching towards the horizon, Nuenen, October 1884.

II. *Alexander Reid*, Vincent's Scottish art dealer friend, Paris, spring 1887.

III. *The Arlésienne,* with Dickens's *Christmas Tales* on the table, Saint-Rémy, February 1890.

IV. *Vincent's Bedroom*, inspired by Vincent's favourite novel by George Eliot, Arles, October 1888.

V. *Memory of the Garden at Etten,* in which Vincent imagined the younger woman was from a Dickens novel, Arles, November 1888.

VI. *Gauguin's Chair*, inspired by Dickens's 'empty chair', Arles, November 1888.

VII. *Vincent's Chair,* based on a premonition of his own death, Arles, November 1888. (National Gallery, London)

VIII. *At Eternity's Gate,* based on Arthur Houghton's illustration for Dickens's
Hard Times, Saint-Rémy, March-April 1890.

Artist

'My not being fit for business or professional study does not prove at all that I am not fit to be a painter. On the contrary, if I had been able to be a clergyman or an art dealer, then perhaps I should not have been fit for drawing or painting.' –
Vincent to Theo, The Hague, spring 1882.[1]

77. Portrait of Vincent by the English artist Horace Livens, the first artist known to have painted him. The two men met at the Antwerp Academy in February 1886 and they later corresponded in English. *'I am not an adventurer by choice, but by fate.'* Vincent to Livens, September 1887.[6]

VINCENT DECIDED to leave Sien, and in September 1883 he departed from The Hague, full of sadness at their failure. He went not to London, as he had so often talked of doing, but to Drenthe, a desolate area in the north of the Netherlands, where he drew and painted. Life there was tough and lonely, and three months later he gave up. Reluctantly he returned to his parents, who had moved the previous year to Nuenen, in the east of Brabant. His parents now regarded him as 'eccentric'. Although staying under the same roof with them, he lived separately and devoted all his efforts to painting. Theo, who by this time was working for Goupil's in Paris, had remained Vincent's only close friend. He sent his older brother payments to enable him to work at his art, and the two corresponded regularly.

Theo's visit to London on Goupil's business in August 1884 once more triggered off Vincent's memories of England. Vincent wrote to his brother: 'How I should love to walk with you in London, particularly in real London weather when the city, especially in certain old parts near the river, has aspects that are very melancholy but at the same time have a remarkably striking character, which some present-day English artists have begun to make after they learned to observe and to paint from the French.' Vincent also asked Theo to pass on his greetings to his former boss, Mr Obach: 'remember me to Mr O if you bump into him.'

Vincent then went on to recall some of the paintings which he remembered seeing a decade before: Constable's *Cornfield* at the National Gallery and *Valley Farm* at South Kensington (now the Victoria and Albert Museum), Millais' *Chill October*, drawings by Fred Walker and George Pinwell (who had both died tragically young in 1875), and the great work by the eighteenth century Dutch artist Meindert Hobbema at the

a

National Gallery, *The Avenue at Middelharnis*.[2]

Although Vincent found satisfaction in drawing and painting, family life at Nuenen became increasingly difficult. He had grown to despise his father's religion, which he partly blamed for his own years of depression. Indeed on one occasion he equated 'melancholia' with 'religious mania', an insight which suggests he was only too aware of the way he had turned to the church as a cure for the depression he had suffered in England.[3] Father died of a heart attack on 26 March 1885, while Vincent was still at Nuenen, but instead of bringing him closer to his mother, this merely exacerbated the tensions. In November he decided to leave for Antwerp.

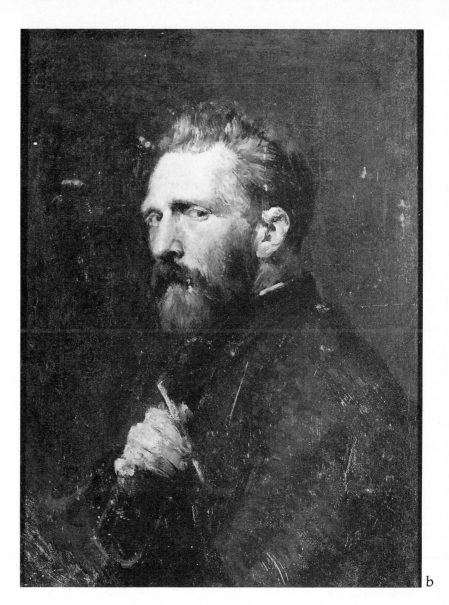

b

78. Two portraits of Vincent done in Paris in 1886 by Scottish artist Archibald Hartrick (a) and Australian artist John Russell (b). *'What really is it that we are now beginning to catch a timid glimpse of, original and enduring? – portraiture . . . Carefully keep my portrait by Russell that I am so fond of.'* – Vincent to Theo, early September 1889.[7]

Vincent enrolled at Antwerp's Academy of Fine Art in January 1886. As in Brussels, he very quickly became dissatisfied with the course and decided to move on again, this time to Paris, where Theo was now the manager of Goupil's gallery (which had become known as Boussod, Valadon & Co) in the Boulevard Montmartre. Vincent arrived in Paris on 1 March 1886, almost exactly a decade after he had been sacked by the company.

This time Paris opened Vincent's eyes to modern art. Under the influence of the Impressionists, his palette was transformed. Vincent attended the studio of Fernand Cormon and for the first time since he had left Goupil's, he met a wide range

I heard Rodin had a beautiful head at the Salon.
I have been to the seaside for a week and very likely am going thither again soon. – Flat shore sands – fine figures there like Cimabue – straight stylish. Am working at a Sower.

The great field all violet. The sky & sun very yellow. It is a hard subject to treat. Please remember me very kindly to mrs Russell – and in thought I heartily shake hands. yours very truly. Vincent

79. Vincent corresponded with Russell in English. *'Am working at a Sower: the great field all violet the sky and sun very yellow. It is a hard subject to treat. Please remind me very kindly to Mrs Russell – and in thought I heartily shake hands. Yours very truly, Vincent.'* – Vincent to Russell, 17 June 1888.[8]

of artists. These included Emile Bernard, Edgar Degas, Paul Gauguin, Camille and Lucien Pissarro, Paul Signac, Georges Seurat and Henri de Toulouse-Lautrec, as well several English-speaking painters, the Australian John Russell, the American Frank Boggs, and two Scotsmen, Archibald Hartrick and Alexander Reid. Like Harry Gladwell, Reid was the son of a British art dealer who had been sent to Paris to learn the trade [Plate II].

80. *Mother*, painted from a photograph in September 1888. *'Mother's photograph gave me very great pleasure, because you can see she is well, and because she still has such a lively expression.'* – Vincent to Theo, 22 September 1888.[9]

Although Vincent and Theo were extremely close, they found it very difficult to live together. Tensions mounted at their flat, at 54 rue Lepic, at the southern end of Montmartre. Vincent became increasingly restless, and on 20 February 1888 he set off again, heading for Provence in the hope that other artists would follow him to establish 'a studio of the South'.

Just six days after his arrival in Arles, he suggested to Theo that they should join together with his former boss from The Hague to deal in Impressionist paintings. 'Tersteeg . . . would have a permanent exhibition of the Impressionists in London, you in Paris, and I should begin in Marseille,' he explained.[4] Five months later he returned to the idea, saying that 'if I were not broke and crazy with this blasted painting, what a dealer I'd make for the Impressionists.' He even talked of asking Boussod to take him back on his old wages to join Theo to sell

141

Impressionist pictures in London. Writing from Provence, at the height of the summer, he added that the only problem with London was the fog – although he commented that the climate in England was still 'infinitely better than the Congo.'[5]

Vincent's attitude towards art dealers was ambivalent. He tried to interest galleries in his work. Several times he went to Tersteeg to suggest that Goupil's might stock his work. He also approached Van Wisselingh, his old friend from London who was now an established dealer in The Hague. But the response was always the same: he must improve his technique and make his work more 'commercial'.

It is usually said that Vincent sold only one oil painting during his entire life, *The Red Vines*, which was sold at an exhibition in Brussels just five months before his death. But there is evidence that before then he sold a painting in London, and this might explain his idea of returning to England as a dealer. A letter dated 3 October 1888 from Theo to London art dealer Sully & Lori has been found which refers to the purchase of a Corot landscape and a 'self-portrait by V. van Gogh'. This does not seem to refer to any of the known self-portraits, and the letter raises the intriguing possibility that the picture could still be somewhere in England, unidentified.

Fortunately, Vincent dropped the idea of becoming an art dealer for the Impressionists in London. Instead he stayed on in Arles, where under the strong sun of the South he painted his greatest works.

The Empty Chair

*'Painters . . . dead and buried speak to the next
generation or to several succeeding generations through
their work. Is that all, or is there more to come? Perhaps
death is not the hardest thing in a painter's life.'* –
Vincent to Theo, Arles, 9 July 1888.[1]

VINCENT'S CHAIR is a vivid reminder of how memories from
his years in England stayed with him right until the end of his
life. Painted at Arles in December 1888, immediately before
the crisis with Gauguin, it was inspired by a series of links
between the painter Millais, the illustrator Fildes, and the
writer Dickens.

Soon after his arrival in The Hague, in January 1882, Vincent
had bought a portfolio of prints from the *Graphic*. These
included Fildes's *Houseless and Hungry*, which was
accompanied by a short explanation: 'Mr J. E. Millais RA for-
warded a copy to Mr Charles Dickens, who was so struck with
the originality displayed in the drawing that he engaged Mr
Fildes to illustrate *The Mystery of Edwin Drood*, the work he was
engaged upon at the time of his death.' Vincent later got more
information about the commission eleven months later from
John Forster's *The Life of Dickens*.

Vincent recounted the story to Theo in considerable excite-
ment: 'I see Millais running to Charles Dickens with the first
issue of the *Graphic*. Dickens was then in the evening of his
life, he had a paralysed foot and walked with a kind of crutch.
Millais says that while showing him Luke Fildes's drawing
Homeless and Hungry [sic], of poor people and tramps in front
of a free overnight shelter, Millais said to Dickens, "give him
your *Edwin Drood* to illustrate," and Dickens said, "very well."
Edwin Drood was Dickens's last work, and Luke Fildes, brought
into contact with Dickens through those small illustrations,
entered his room on the day of his death, and saw his empty
chair; and so it happened that one of the old numbers of the
Graphic contained that touching drawing, *The Empty Chair*.'[2]

The three characters linked in this account were all of special
significance to Vincent. When Vincent had arrived in London,
he had immediately named Millais as one of his favourite
artists. 'There are clever painters here, among others,

81. Fildes's *Empty Chair* from the *Graphic*, Christmas 1870 issue. Fildes had visited Dickens's home at Gad's Hill just after his death, and was struck by the chair which the novelist would never use again. *'Empty chairs – there are many of them, there will be even more.'* – Vincent to Theo, December 1882.[15]

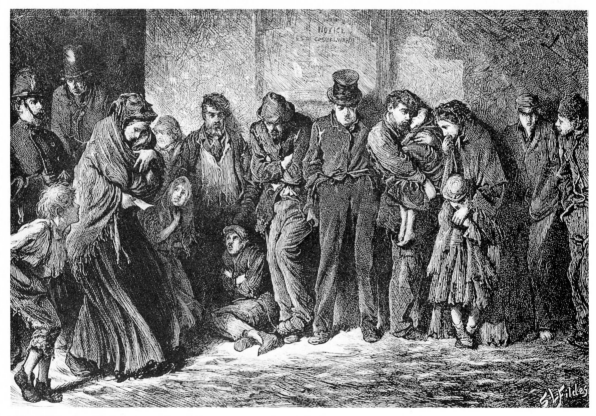

82. Fildes's *Houseless and Hungry* which appeared in the first issue of the *Graphic* on 4 December 1869. *'For 5 guilders I chose the best from an enormous pile of* Graphics *and* London News. *There are things among them that are superb, for instance, The Houseless and Homeless [sic] by Fildes (poor people waiting in front of a free overnight shelter).'* – Vincent to Theo, 7 January 1882.[16]

Millais . . . his things are beautiful,' he had told Theo on 20 July 1873.[3] After he left England, he recalled that 'once I met the painter Millais on the street in London, just after I had been lucky enough to see several of his pictures.'[4] Still later Vincent described Millais' work as 'one of the highest and noblest expressions of art'.[5]

Vincent did not 'discover' Fildes until he moved to The Hague. The English black-and-white artist was one of the *Graphic*'s best illustrators, and his *Houseless and Hungry* was among Vincent's favourite prints. In 1874, at the Royal Academy, he had also seen Fildes's later painted version, entitled *Applicants for Admission to a Casual Ward*. Fildes had a strong influence on Vincent's own work, and this can be seen in his drawing of *The State Lottery Office*, done in October 1882.

Dickens was the English writer whom Vincent admired most. He read him throughout his life and his letters are full of references to the novelist. On arriving in Dordrecht in 1877, he described how his lodgings overlooked old houses covered with ivy. 'A strange old plant is the ivy green,' he quoted from *Pickwick Papers*.[6] A few months later he told Theo he had breakfasted on a piece of dry bread and a glass of beer. 'That is what Dickens advises for those who are on the point of committing suicide, as being a good way to keep them, at least for some time, from their purpose,' he joked.[7]

When he visited his parents at Etten in August 1879, his mother reported that 'he reads Dickens all day and speaks only when he is spoken to.'[8] Among the books he read in Holland were *A Tale of Two Cities*, *A Child's History of England*, *Hard Times*, *Little Dorrit*, and *Martin Chuzzlewit*. When he brought new editions of *A Christmas Carol* and *The Haunted Man* in The Hague, he explained to Van Rappard: 'I have reread these two "children's tales" nearly every year since I was a boy, and they are new to me again every time.' Vincent also liked to draw parallels between literature and art. 'There is no writer, in my opinion, who is so much a painter and a black-and-white artist as Dickens,' he told Van Rappard.[9]

Years later, in Arles, Vincent was still enjoying Dickens. In November 1888 he used an analogy from a Dickens novel in describing his painting *Memory of the Garden at Etten* (Plate V). He explained to his sister Wil: 'Let us suppose that the two ladies out for a walk are you and our mother . . . The sombre violet with the blotch of violent citron yellow of the dahlias suggests Mother's personality to me. The figure in the Scotch plaid with the orange and green checks stands out against the sombre green of the cypress, which contrast is further accentuated by the red parasol – this figure gives me an

impression of you like those in Dickens's novels.'[10] Early in 1890 Vincent re-read *Christmas Tales*, and he included a copy of the book along with American writer Harriet Beecher Stowe's *Uncle Tom's Cabin* in a painting of the Arlésienne (Plate V).

Edwin Drood, the unfinished book which inspired the 'empty chair' story, was among his favourite Dickens novels. In June 1882, when he caught gonorrhea, the book gave him comfort. Writing from his hospital bed, he told Theo: 'I have . . . a few volumes of Dickens, including *Edwin Drood* . . . Good God, what an artist! There's no one like him.'[11] When Vincent came out of hospital he bought a copy of Fildes's print which the *Graphic* had published to mark the death of Dickens. 'I am also very anxious to show you the wood engravings. I have a splendid new one, a drawing by Fildes, *The Empty Chair of Dickens* from the *Graphic* of 1870,' he wrote to his brother.[12]

At one level Vincent's 'empty chair' was inspired by a link between an English painter, illustrator and writer, but characteristically he used the story to trigger off his own very personal vision. Pointing out that there would be more deaths, he told Theo that 'sooner or later there will be nothing but empty chairs in place of Herkomer, Luke Fildes, Frank Holl, William Small, etc. And yet the publishers and dealers . . . how hard-hearted they are, how mistaken they are, if they think they can make everybody believe that material grandeur outweighs moral grandeur.'[13]

Vincent saw close links between parting and death. Parting had always caused him great pain, right from his childhood days at Mr Provily's school. Years later, just after Father had visited him in Amsterdam in February 1878, Vincent was

146

moved by the sight of the chair where he had been sitting: 'After I had seen Father off at the station and had watched the train go out of sight, even the smoke of it, I came home to my room and saw Father's chair standing near the little table on which the books and copybooks of the day before were still lying; and though I know that we shall see each other again pretty soon, I cried like a child.'[14]

These emotions later emerged in his art. In *At Eternity's Gate*, drawn in 1882, Vincent depicted a dying man, sitting by the fire awaiting his end on a chair that he would soon vacate. Eight years later, while at the asylum in Saint-Rémy, he did a painted version of this picture, the only time he ever went back to an earlier black and white work and translated it into colour (plate VIII).

Among Vincent's greatest works are two simple paintings he did of Gauguin's chair and his own 'empty chair' (Plates VI and VII). The debt to Dickens and Fildes is clear. Even the shape of Gauguin's chair is reminiscent of Dickens's. The candle, still alight, must also be a reference to one of Fildes's illustrations for *Edwin Drood*. Twelve years after he had left London, Vincent was still inspired by the English writers and artists who had meant so much to him. Sadly, the two paintings of 'empty chairs' were a premonition of Gauguin's imminent departure and his own tragic end.

Theo's Love

*'I should have . . . a home of my own, which frees the
mind from the dismal feeling of being a homeless wanderer.
That is nothing when you are an adventurer of twenty,
but it is bad when you have turned thirty-five.' –*
Vincent to Theo, Arles, 8 September 1888.[1]

84. Theo, just before his marriage. *'All your kindness to me seemed greater than ever to me today . . . Only transfer this affection to your wife.'* – Vincent to Theo, 21 April 1889.[14]

85. Jo Bonger, who married Theo in 1889, with the baby Vincent. *'Last Sunday Theo, his wife and their child were here . . . for me it is a very reassuring feeling to be living so much nearer to them.'* – Vincent to Mother, 13 June 1890.[15]

VINCENT, WHO HAD FAILED in love, finally died when his brother found a lover. Theo was the only person who was convinced of Vincent's artistic talent. It was Theo who supported his brother financially, over many years. Most importantly, he was Vincent's emotional support and his life-long friend. When Theo fell in love, this not only posed a threat to his brother, but was also a reminder of Vincent's tragic failure with Eugenie and Kee.

Theo's son was later convinced that it was his parents' marriage – and his own birth – which had killed his uncle. 'The trouble with Gauguin in Arles started right after Vincent heard from Theo that he intended to marry. Other crises came about after Theo's marriage, after the announcement that a baby was expected and after his birth. It must have passed through his mind that he would lose his support, though he never mentioned it and it never came about,' wrote Theo's son.[2]

The tragedy began to unfold on the night before Christmas Eve, 1888. Vincent approached Gauguin, who had been staying with him at the Yellow House for three months, and threatened him with an open razor. Gauguin fled, and later that evening Vincent turned the blade on himself, slicing off the lower part of his left ear. He carefully wrapped up the small piece of flesh and took it to a brothel, where he presented it to a prostitute called Rachel. This mutilation marked the beginning of a series of mental crises during which Vincent would fall into a deep depression, hardly aware of what he was doing.

Although the fundamental causes of Vincent's mental problems were complex, a major trigger seems to have been Theo's love affair. In late 1888 Theo fell in love with Jo Bonger, sister of his friend Andries, and they became engaged just before Christmas. Vincent may not have learned of their formal engagement until after the incident with Gauguin, but he must

have realised that marriage was in the air.

As soon as Theo heard about Vincent's attack, he travelled down to Arles immediately, postponing a visit to Holland to announce the engagement. In hospital, he told Vincent more about his relationship with Jo and a week later, after Theo's return to Paris, Vincent reacted to news of his brother's new relationship by saying, 'I cannot tell you how glad I am that you have made peace, and even more than that, with the Bongers.'[3] Superficially Vincent accepted the engagement, as he had done with Eugenie fifteen years earlier, but he sometimes seemed less than enthusiastic. 'I had had a letter this morning from your fiancée announcing the engagement. So I have already sent her my sincere congratulations in reply, and herewith I repeat them to you,' was all Vincent wrote to Theo when told of the formal engagement.[4]

Theo understood his brother's feelings. 'It is a great sorrow to me to know that, precisely at the time when in all probability I am going to have days of happiness with my dear Jo, you are passing through days of misery,' he told Vincent.[5] Just before the wedding, Vincent replied with a sad note: 'A few lines to wish you and your fiancée very good luck in these days. It is a sort of nervous affliction of mine that on festive occasions I generally have difficulty in formulating good wishes, but you must not conclude from this that I wish you happiness less earnestly than anyone else.'[6]

After the wedding, on 17 April 1889, Theo and Jo tried to make him feel part of their family. Jo began calling Vincent 'brother' and writing on 8 May, she said: 'It is high time at last that your new little sister had a chat with you herself, instead of leaving it to Theo to send her regards . . . we are really and truly brother and sister, and I should be so very happy if you knew me a little too, and, if possible, loved me a little.'[7] Soon after the wedding, Vincent decided to enter an asylum in nearby Saint-Rémy-de-Provence. At the very moment when Theo and Jo began married life, Vincent was moving into the isolation of a mental asylum. On 5 July Jo wrote to Vincent announcing her pregnancy. 'Next winter, towards February probably, we hope to have a baby, a pretty little boy – whom we are going to call Vincent, if you will kindly consent to be his godfather,' Jo explained.[8] Although Vincent replied that he was 'very glad', another mental crisis followed shortly afterwards.[9] Two months later Vincent told Theo that 'I so wish that you were two years further on and that these first days of your marriage, however lovely they must be at moments, were behind you.'[10]

On 29 January 1890, the day before the birth of his namesake,

b

LA VEILLÉE. — Composition et dessin de J. F. Millet, gravure de La Vieille.

a

86. Vincent's print of Millet's *Night* (engraved by Jacques-Adrien Lavielle) with the version which he did in October 1889. *'Painting from these drawings of Millet's is much more* translating them into another tongue *than copying them.'* – Vincent to Theo, 2 November 1889.[16]

Vincent suffered another mental attack. As his condition deteriorated, he looked back at his past for inspiration. The previous year he had been comforted by re-reading Dickens and Shakespeare. At Saint-Rémy he turned to his favourite pictures by Millet, doing twenty coloured versions of prints by the 'painter of the peasants'. Vincent also consciously searched for motifs from his early years. 'While I was ill I nevertheless

151

a

did some little canvases from memory which you will see later, memories of the North,' he told Theo in April 1890.[11]

Yearning for the outside world, he decided to leave the asylum and in May 1890 he headed for Auvers-sur-Oise, a village 22 miles north of Paris which had been recommended to him by his painter friend Camille Pissarro. Vincent also knew it as the place where Barbizon artist Charles-François Daubigny lived until his death in 1878 and where his beloved Corot had painted.

Stopping in Paris for three days, Vincent stayed at rue Lepic, seeing both Jo and baby Vincent for the first time. Ever since Theo's engagement, Vincent had feared that he might lose his financial support, now there were two more mouths to feed. These financial worries were exacerbated by Theo's problems

87. *Prisoners Exercising*, painted in the Saint-Rémy asylum, January 1890. It was based on an engraving from Gustave Doré's book *London: A Pilgrimage*. Vincent squared-up a print of *Newgate*, for his painting. *'I have tried to copy . . . Doré; it is very difficult.'* – Vincent to Theo, 10 February 1890.[17]

b

at Goupil's, caused by his insistence on trying to sell the Impressionists along with their more traditional artists. By June Theo was so angry over his treatment that he considered resigning from Goupil's to set up on his own. For Vincent, this brought back memories of his own painful time with the gallery.

On 27 July, two months after his arrival at Auvers, Vincent climbed the hill behind the village and walked into the wheatfields where he had often painted. In a moment of utmost despair, he shot himself in the stomach. His wound was not immediately fatal, and he staggered back to the inn where he was staying. Painfully, he climbed the stairs to his attic bedroom – a small blue-painted room with a sloping roof, just like the one of his childhood.

It was not until the following morning that Theo was contacted at Goupil's and given the tragic news. He rushed to his brother's bedside, and later the same day he wrote to his new wife Jo: 'Poor fellow, very little happiness fell to his share, and there are no illusions left him. The burden grows too heavy at times, he feels so alone. He often asks after you and the baby, and said that you could not imagine there was so much sorrow in life. Oh! if we could only give him some new courage to live.'[12] That evening Vincent continued to smoke his trusty pipe, and early in the morning of 29 July 1890 he collapsed in his brother's arms, dead at the age of 37.

Vincent was refused a church burial. Auvers' Catholic church, which he had painted against a vibrant purple sky just a few weeks earlier, barred its doors to him because he had taken his own life. The Dutchman, who fourteen years earlier had been attracted to the light of 'a very beautiful Catholic church' near Isleworth, was now an outcast. Auvers even refused to provide the parish hearse. Fortunately, the neighbouring village was more tolerant, and they lent their hearse to carry Vincent's body up the hill to the cemetery beside the wheatfields.

'We are pilgrims, our life is a long walk or journey from earth to heaven . . . We only pass through the earth, we only pass through life, we are strangers and pilgrims on earth,' Vincent had told the congregation of Richmond Methodist Church. For the past fourteen years Vincent had travelled, constantly on the move. The lack of a home had taken its toll, and at thirty-seven he was worn out. 'There is sorrow in the hour of death, but there is also joy unspeakable when it is the hour of death of one who has fought a good fight.'[13]

* * *

Vincent's suicide led to Theo's death. After Theo had lost his brother, he himself suffered a mental breakdown and he was confined to hospital in Holland, dying there on 25 January 1891. His body was later moved to the cemetery in Auvers and the two brothers now rest beside each other, their graves covered with ivy. On the wall behind is a simple plaque which reads: 'Ivy as a symbol of constant affection links Theo's and Vincent's graves, two brothers who loved each other tenderly.'

Van Gogh's suicide passed virtually unnoticed in the art world and it was not until 1910 that Londoners had their first chance to see the work of the Dutch artist who had spent his early adult years in their city. Twenty of his works were included in an exhibition on *Manet and the Post-Impressionists*, which opened at the Grafton Galleries in November. It was

88. Eugenie Loyer and her school at 31 Gap Road, Wimbledon, about 1900. '*A woman is not old as long as she loves and is loved.*' – Vincent to Theo, 31 July 1874.[18]

this exhibition which led to the creation of the expression Post-Impressionism. Many visitors laughed at Van Gogh's paintings and artist Walter Sickert wrote a damning review, admitting that he had 'always disliked Van Gogh's execution.' Among the pictures on display was the version of *Sunflowers* which was to sell for £25 million in 1987.

The English friend who had meant most to Vincent was still alive when the London exhibition opened. Eugenie, then a 56-year-old widow, had moved to Wimbledon, where she continued to run the school she had taken over from her mother. Five months after the exhibition closed, on 18 June 1911, she died from a heart attack. We shall never know whether Eugenie ever discovered that the young lodger who had sketched Hackford Road, in a futile attempt to win her heart, had ultimately become a great artist.

Bibliography

The best general biography is Marc Tralbaut's *Vincent van Gogh* (Chartwell Books, 1969). Other useful biographies are Humberto Nagera, *Vincent van Gogh: A Psychological Study* (Allen & Unwin, 1967), Albert Lubin, *Stranger on the Earth: A Psychological Biography of Vincent van Gogh* (Henry Holt, 1972) and A. M. Hammacher, *Van Gogh: A Documentary Biography* (Thames & Hudson, 1982). Also recommended are Bruce Bernard (ed), *Vincent by Himself* (Orbis, 1985), Susan Stein (ed), *Van Gogh: A Retrospective* (Macmillan, 1987), Evert van Uitert and Michael Hoyle (eds), *The Rijksmuseum Vincent van Gogh* (Rijksmuseum Vincent van Gogh, 1987), and Melissa McQuillan, *Van Gogh* (Thames & Hudson, 1989). The earliest biography to be published in English, Louis Piérard, *The Tragic Life of Vincent van Gogh* (John Castle, 1925), is important.

Van Gogh's own letters give a unique first-hand impression of the artist's life. These are published in the three-volume *Complete Letters of Vincent van Gogh* (Thames & Hudson, 1958). Volume I also contains the important *Memoir* by Vincent's sister-in-law Jo Bonger. The letters from Van Gogh's English period (and Paris interlude) are in volume I (Letters 9 to 82, pp. 7–85). Extracts from these early letters are also published in Vincent W. van Gogh, *Vincent van Gogh on England* (Rijksmuseum Vincent van Gogh, 1968).

The unpublished family letters, which were sent to Theo by other members of the family, have provided a great deal of new material for this book. There are approximately four hundred letters dating from 1873–76. They are held at the Rijksmuseum Vincent van Gogh in Amsterdam, and permission from the Vincent van Gogh Foundation is required to study them.

Jan Hulsker's outstanding *The Complete Van Gogh* (Phaidon, 1980) illustrates all paintings and drawings from April 1881 onwards, but unfortunately omits the early drawings. The catalogue by Jacob de la Faille, *The Works of Vincent van Gogh* (Weidenfeld & Nicolson, 1970), reproduces the early drawings in its section on 'Juvenilia' by Jan van Gelder, pp. 600–7. Also useful on these early drawings is J. van Gelder, 'The Beginnings of Vincent's Art' in *Catalogue of Vincent van Gogh* (Rijksmuseum Kröller-Müller, 1959), pp. xv-xx.

The most important study on the impact of Van Gogh's period in England is the catalogue, *English Influences on Vincent van Gogh* (Arts Council, 1974). Professor Ronald Pickvance's catalogue is a pioneering work which formed a very useful

basis for this book.

The only person with direct knowledge of Van Gogh's early years who has written their own account is his sister Lies, who as Elizabeth du Quesne-van Gogh published her *Personal Recollections of Vincent van Gogh* (Constable, 1913).

Kenneth Wilkie, *The Van Gogh Assignment* (Paddington Press, 1979) retraces the artist's footsteps. It is most important for the account of the author's discovery of the Hackford Road drawing (pp. 32–55).

Van Gogh's albums of writings which he copied out for Theo, Matthew Maris and Annie Slade-Jones are reproduced in *Vincent van Gogh's Poetry Albums*, edited by Fieke Pabst and published as the first volume of *Cahier Vincent* (Rijksmuseum Vincent van Gogh, 1988). The sketchbook for Betsy Tersteeg is reproduced in Anna Szymańska, *Unbekannte Jugendzeichnungen Vincent van Goghs und das Schaffen des Kunstlers in den Jahpen 1870–1880* (in German) (Berlin: Henschel, 1967).

On the British artists who influenced Van Gogh, see the catalogue of the excellent Manchester City Art Galleries' exhibition, *Hard Times: Social Realism in Victorian Art* edited by Julian Treuherz (Lund Humphries, 1987). It has chapters on Holl, Fildes and Herkomer, as well as a chapter by Louis van Tilborgh on 'Vincent van Gogh and English Social Realism'. On Boughton, Van Gogh's favourite English artist, see Josefine Leistra, *George Henry Boughton; God Speed!* (in Dutch) (Rijksmuseum Vincent van Gogh, 1987) and Hope Werness, 'Vincent van Gogh and a Lost Painting by G. H. Boughton' (in English) in *Gazette des Beaux-Arts*, 1985, pp. 71–5. See also L. Fildes, *Luke Fildes RA: A Victorian Painter* (Michael Joseph, 1968) and *Sir Hubert von Herkomer*, a catalogue of an exhibition held at Watford Museum in October 1988.

The 1983 Royal Academy catalogue by Ronald de Leeuw, John Sillevis and Charles Dumas, *The Hague School: Dutch Masters of the 19th Century* (Weidenfeld & Nicolson, 1983) is the best account of the Dutch painters who influenced Van Gogh. On Matthew Maris see Ernest Fridlander, *Matthew Maris* (Warner, 1921) and David Croal Thomson, *The Brothers Maris (James-Mathew-William)* (The Studio, 1907). Louis van Tilborgh, *Van Gogh and Millet* (Rijksumseum Vincent van Gogh, 1988) deals with Van Gogh's favourite French artist. See also Charles Cheetham, *The Role of Vincent van Gogh's Copies in the Development of his Art* (New York: Garland, 1976).

Alan Bowness's 'Vincent in England' in the catalogue *Vincent van Gogh* (Arts Council, 1968) provides a useful general introduction (pp 5–15). For details of Miss Applegarth's school in Welwyn, see William Branch Johnson, *Welwyn, By and Large*

(privately published, 1967), p. 44. On the discovery of Van Gogh's name in the British Museum's visitors' book see Griselda Pollock, 'Vincent van Gogh, Rembrandt and the British Museum', *Burlington Magazine*, November 1974, pp. 671–2. Two of the art dealers Van Gogh knew in London feature in a booklet by Brian Gould, *Two Van Gogh Contacts: E. J. van Wisselingh and Daniel Cottier* (privately published, 1969).

For the discovery of Van Gogh's lodgings in Ramsgate, see the unpublished paper by Ruth Brown, 'Happy Times Here in Ramsgate for Vincent van Gogh', June 1982 (available at Ramsgate Reference Library). On the Revd Thomas Slade-Jones, who employed Van Gogh in Isleworth, see the unpublished study by George Lawrence, 'The Methodism of Vincent van Gogh' (1979). John Taylor, 'Van Gogh in England' in *Burlington Magazine*, September 1964, pp. 419–20 gives details of Turnham Green Congregational Church records. The history of the church is covered in *Chiswick High Road Congregational Church Illustrated Monthly Magazine*, February, March and April 1890. On the church where Van Gogh gave his first sermon, see the booklet by Francis Burns, *Richmond Methodist Church 1773–1968: A Short History of Methodism in Richmond* (privately published, 1968), especially pp.10–6 and David Bruxner, 'Van Gogh's Sermon', in *Country Life*, 11 November 1976, pp 1426–8.

The journal *Vincent*, published by the Rijksmuseum Vincent van Gogh, from 1970–6, contains useful articles, particularly Anne Wylie, 'Vincent's Childhood and Adolescence', vol 4, no 2, pp. 4–17.

For detailed studies of Van Gogh's later life the most useful sources are four recent exhibition catalogues: *Van Gogh in Brabant* ('s-Hertogenbosch: Noordbrants Museum, 1987), *Van Gogh à Paris* (in French) (Paris: Musée d'Orsay, 1988), *Van Gogh in Arles* (New York: Metropolitan Museum of Art, 1984), *Van Gogh in Saint-Rémy and Auvers* (New York: Metropolitan Museum of Art, 1986). Johannes van der Wolk, *The Seven Sketchbooks of Vincent van Gogh* (Thames & Hudson, 1987) also provides important new material.

On the black-and-white illustrators see the exhibition booklets *Vincent van Gogh: The Influences of Nineteenth Century Illustrations* (Tallahassee: Florida State University, 1980) and *Les sources d'inspiration de Vincent van Gogh* (in French) (Paris: Institut Néerlandais, 1972).

On Van Gogh's friend Alexander Reid see Tom Honeyman, 'Van Gogh: A Link with Glasgow', *Scottish Arts Review*, vol ii, no 2 (1948), pp 16–21 and the exhibition catalogues *A Man of Influence: Alex Reid 1854–1928* (Scottish Arts Council, 1967) and *Alex Reid & Lefevre 1926–1976* (Lefevre Gallery, 1976). For an

account of Van Gogh by another Scottish artist friend see Archibald Hartrick, *A Painter's Pilgrimage through Fifty Years* (Cambridge University Press, 1939), pp. 39–53.

The sale of Van Gogh's self-portrait to an English dealer is revealed in Marc Tralbaut, *De Gebroeders Van Gogh* (in Dutch), (1964). For Theo's involvement with Goupil's, see John Rewald, 'Theo van Gogh as an Art Dealer' in his *Studies in Post-Impressionism* (Thames & Hudson, 1986), pp. 7–103.

Finally, to see Van Gogh's paintings the most important museums are both in the Netherlands, the Rijksmuseum Vincent van Gogh in Amsterdam (Paulus Potterstraat 7, telephone 20–5705200) and the Rijksumuseum Kröller-Müller, set in a beautiful national park near Arnhem (De Hoge Veluwe, Otterlo, telephone 8382–1241). The Amsterdam museum also has an excellent library and documentation centre.

None of Van Gogh's drawings from his English period remain in Britain and most are at the Rijksmuseum Vincent van Gogh in Amsterdam. They are not normally on display and can only be seen by prior arrangement. British galleries with paintings by Van Gogh are in Birmingham (Barber Institute), Cambridge (Fitzwilliam Museum), Cardiff (National Museum of Wales), Edinburgh (National Gallery of Scotland), Glasgow (City Art Gallery), London (Courtauld Institute, National Gallery and Tate Gallery) and Oxford (Ashmolean Museum).

Picture credits

Vincent van Gogh Foundation/Rijksmuseum Vincent van Gogh, Amsterdam (kindly supplied through Antonia Daalder-Vos, Stedelijk Museum): 1, 2, 6, 7, 8, 11, 14a, 16, 18, 22, 24, 26, 27a, 28, 30, 33, 34a, 37, 38, 48, 50, 52, 53, 54, 56a, 67, 70, 73a, 74, 75, 76, 78b, 82, 84, 85, 86, 87b, 88, VI.
Acquavella Galleries, New York (painting now in private collection): 27b.
Sue Adler: 29, 32, 40, 56b, 62.
Bibliothèque Nationale, Paris (H66751): 25.
British Museum, London, reproduced by courtesy of the Trustees: 20.
Corporation of London, Greater London Record Office (N/C/35/36) (courtesy of Thames North Province of United Reform Church): 51, 58.
Stichting P. en N. de Boer Foundation, Amsterdam: 72.
Manchester City Art Galleries, 1865 edition of *Hard Times*: 73b.
Glasgow Art Gallery & Museum: II.
Guildhall Library, City of London: 49
Justin K. Thanhauser Collection, Soloman R. Guggenheim Museum, New York (photograph by Robert E. Mates): 79.
Haags Gemeentemuseum, The Hague: 4.
Hermitage Museum, Leningrad (photograph from Scala, Turin): V.
County Record Office, Hertfordshire County Council (D/P119 1/47): 43.
Manchester City Art Galleries, 1865 edition of *Hard Times*: 73b.
Yoke Matze: 13, 14b, 15, 35, 36, 39, 41, 42, 44, 52, 61.
Catherine Mowbray (painting in private collection): 10c.
Musées Nationaux, Musée d'Orsay, Paris: 31, 59, 62, IV.
National Gallery, London, reproduced by courtesy of the Trustees: VII.
Norton Simon Art Foundation, Pasadena, California: 80.
Perth Museum and Art Gallery, on loan from a private collection: 21.
Pushkin Fine Art Museum, Moscow: 87.
Rijksmuseum, Amsterdam: 60
Rijksmuseum Kröller-Müller, Otterlo: 63, 64, 65, I,III, VIII.
Royal Commission on the Historical Monuments of England (11726): 55b.
Royal Holloway and Bedford New College, Egham, Surrey: 10d.
Jan Nieuwenhuizen Segaar, The Hague: 66.
Stichting tot Bevordering van het Kunsthistorisch Onderzoek in Nederland, The Hague: 17, 34b, 55a.
Tate Gallery, London: 10b.
Tate Gallery Archive, London: 47.
Toledo Museum of Art, Ohio, 10a.
Wallace Collection, London, reproduced by permission of the Trustees: 19.
Walsall Metropolitan Borough Council, Museum and Art Gallery, Garman Ryan Collection: 71.

Chronology

30 March 1853	Vincent van Gogh born in Zundert, eldest son of Pastor Theodorus and Anna Carbentus.
1 May 1857	Birth of Theodorus (Theo).
1 October 1864	Attends Jan Provily's school at Zevenbergen.
1 September 1866	Attends state secondary school at Tilburg.
30 July 1869	Starts work at Goupil's gallery in The Hague.
19 May 1873	Transferred by Goupil's to London.
Late August 1873	Moves to new lodgings with the Loyers at 87 Hackford Road, Brixton.
27 June 1874	Leaves for short summer holiday with family in Helvoirt.
15 July 1874	Arrives back in London with his sister Anna.
Early August 1874	Declares his love for Eugenie Loyer, faces rejection and a few days later moves to Ivy Cottage, 395 Kennington Road.
Mid-November 1874	Transferred temporarily to Goupil's in Paris.
c24 December 1874	Leaves for Christmas holiday at Helvoirt.
c2 January 1875	Returns to London.
May 1875	Transferred again to Paris.
24 December 1875	Goes home to Etten for Christmas.
c2 January 1876	Returns to Paris, and is sacked.
31 March 1876	Leaves Paris for a short holiday in Etten.
14 April 1876	Goes to Ramsgate, where he works as a teacher for William Stokes and lives at 11 Spencer Square.
12 June 1876	Walks to Welwyn to see Anna, and goes on to Isleworth, where Mr Stokes opens new school at 183 Twickenham Road.
3 July 1876	Leaves Mr Stokes and joins school of the Rev Thomas Slade-Jones at 158 Twickenham Road.
20 December 1876	Arrives back in Etten for Christmas, decides not to return to England.

January 1877	Starts working as a bookseller in Dordrecht.
May 1877	Moves to Amsterdam, where he studies Greek and Latin for university entrance.
July 1878	Abandons studies in Amsterdam and enrols in theological college near Brussels.
November 1878	Fails to qualify at theological college and returns to Etten.
December 1878	Leaves for the Borinage, to become a preacher in Wasmes.
August 1879	Works on his own as a preacher in Cuesmes.
August 1880	Abandons missionary work, to become an artist.
October 1880	Moves to Brussels and enrols at art academy.
April 1881	Returns to Etten.
August 1881	Falls in love with his cousin Kee Vos.
November 1881	Moves to The Hague, where he soon meets the prostitute Sien Hoornik.
September 1883	Breaks with Sien and leaves for Drenthe.
December 1883	Returns to his parents' home at Nuenen.
26 March 1885	Father dies.
Late November 1885	Leaves for Antwerp, where he later enrols at the art academy.
28 February 1886	Arrives in Paris, where Theo is working for Goupil's.
20 February 1888	Arrives in Arles, to set up his 'studio of the South'.
23 October 1888	Gauguin joins Vincent in Arles.
23 December 1888	Vincent mutilates his ear after row with Gauguin.
17 April 1889	Wedding of Theo and Jo.
8 May 1889	Moves to asylum in Saint-Rémy-de-Provence.
30 January 1890	Birth of Vincent, son of Theo and Jo.
16 May 1890	Leaves Saint-Rémy.
20 May 1890	Arrives Auvers-sur-Oise.
27 July 1890	Shoots himself in the stomach.
29 July 1890	Dies with Theo by his side.
25 January 1891	Theo dies in Utrecht.

References to Letters

The published letters are available in the three-volume *Complete Letters of Vincent van Gogh* (Thames & Hudson, 1958). Vincent's letters, which were mainly to Theo, are indicated by the numbers 1 to 652. Letters to other important recipients are prefixed by 'R' (Anton van Rappard), 'B' (Emile Bernard) and 'W' (Wil van Gogh). Jo Bonger's *Memoir* is on pages xv-lviii of the first volume. Letters from Theo are prefixed by 'T'.

The unpublished Van Gogh family letters are referred to by a four-digit number prefixed by 'U'. They are deposited at the Rijksmuseum Vincent Van Gogh in Amsterdam, but are only available for consultation with special permission.

Chapter 1

1 5
2 5
3 U2644
4 9a
5 9a
6 10a
7 9
8 10a
9 11
10 5
11 10a
12 A7
13 10
14 37
15 10

Chapter 2

1 617
2 p. xxiv
3 12
4 11
5 10
6 332
7 17
8 249
9 12
10 5
11 7

12 R19
13 17

Chapter 3

1 332
2 11
3 U2673
4 p. 7
5 11
6 20
7 13
8 17
9 157

Chapter 4

1 157
2 U2679
3 U2689
4 U2691
5 15
6 16
7 U2679

Chapter 5

1 157
2 Szymańska p. 73
3 U2710
4 p. xxiv-v

5 14a
6 U2712
7 U2713
8 20
9 21
10 A7
11 U2715
12 20
13 164
14 82a
15 Szymańska, p. 73
16 21

Chapter 6

1 W1
2 21
3 20
4 U2715
5 110
6 U2720
7 U2723
8 U2724
9 U2726
10 U2679
11 U2729
12 p. xxv
13 82a
14 U2333
15 22
16 22

17 25
18 U2337
19 26
20 110
21 374
22 22
23 23
24 25

Chapter 7

1 452
2 26
3 U2338
4 U2341
5 U2339
6 U2345
7 U2356
8 30
9 U2346
10 33
11 36a
12 42
13 29
14 42
15 30
16 32
17 41

Chapter 8

1 108
2 42
3 43
4 44
5 45
6 55
7 51
8 56
9 46
10 47
11 48
12 49
13 358
14 U2225
15 U2224
16 42
17 49

Chapter 9

1 332
2 50
3 U2227
4 p. xxvi
5 315
6 315
7 p. xxv
8 52
9 U2232
10 57
11 56
12 57
13 24
14 p. xxiv
15 U2741
16 p. xxvi
17 347
18 p. xxvi
19 52
20 54
21 57
22 54
23 Hammacher, p. 24
24 59

25 50
26 42
27 408
28 60

Chapter 10

1 82a
2 60
3 61
4 60
5 U2752
6 62
7 67
8 64
9 63
10 63
11 64
12 67
13 64
14 66
15 R43
16 W15
17 63
18 65
19 60
20 72
21 62
22 67
23 61

Chapter 11

1 91
2 69
3 165
4 69
5 69
6 69a
7 69a
8 U2756
9 69
10 82a
11 69
12 91

Chapter 12

1 100
2 70
3 70
4 71
5 122a
6 73
7 74
8 80
9 75
10 76
11 78
12 275
13 76
14 72
15 70
16 78
17 A7
18 76
19 Pabst, p. 66
20 75
21 76
22 63

Chapter 13

1 89
2 80
3 81
4 82
5 81
6 A7
7 79
8 79
9 pp. 87–91
10 82
11 82
12 74
13 80
14 79
15 79
16 74

Chapter 14

1 442
2 82
3 81
4 82
5 82
6 82a
7 U2770
8 92
9 83
10 94a
11 p. xxvi
12 On sketch
13 82
14 84

Chapter 15

1 R13
2 130
3 109
4 109
5 111
6 116
7 111
8 119
9 *Vincent*, 3/1974, p. 32
10 123
11 132
12 133
13 116
14 121
15 109

Chapter 16

1 154
2 136
3 157
4 193
5 164
6 378
7 192
8 13
9 143

Index